Enchanting Elves

Enchanting
ELVES

Paint Elven Worlds and Fantasy Characters

Barbara Lanza

IMPACT
CINCINNATI, OHIO
www.impact-books.com

Published by IMPACT Books, an imprint of F+W Media, Inc., 4700 East Galbraith Road, Cincinnati, Ohio, 45236. (800) 289-0963. First Edition.

Other fine IMPACT Books are available from your local bookstore, art supply store or visit us at our website www.fwmedia.com.

13 12 11 10 09 5 4 3 2 1

DISTRIBUTED IN CANADA BY FRASER DIRECT
100 Armstrong Avenue
Georgetown, ON, Canada L7G 5S4
Tel: (905) 877-4411

DISTRIBUTED IN THE U.K. AND EUROPE BY DAVID & CHARLES
Brunel House, Newton Abbot, Devon, TQ12 4PU, England
Tel: (+44) 1626 323200, Fax: (+44) 1626 323319
Email: postmaster@davidandcharles.co.uk

DISTRIBUTED IN AUSTRALIA BY CAPRICORN LINK
P.O. Box 704, S. Windsor NSW, 2756 Australia
Tel: (02) 4577-3555

Library of Congress Cataloging in Publication Data
Lanza, Barbara.
 Enchanting elves : paint elven worlds and fantasy characters / Barbara Lanza. -- 1st ed.
 p. cm.
 Includes index.
 ISBN-13: 978-1-60061-307-4 (pbk. : alk. paper)
 1. Elves in art. 2. Painting--Technique. I. Title.
ND1460.F32L35 2009
758'.939821--dc22
 2009014745

Edited by Kelly C. Messerly
Designed by Guy Kelly
Production coordinated by Matt Wagner

METRIC CONVERSION CHART		
To convert	to	multiply by
Inches	Centimeters	2.54
Centimeters	Inches	0.4
Feet	Centimeters	30.5
Centimeters	Feet	0.03
Yards	Meters	0.9
Meters	Yards	1.1

ABOUT THE AUTHOR

Barbara Lanza has been imagining fantasy worlds since she was a child on the resort island of Wildwood, New Jersey. Encouraged to develop her artistic talent, she graduated from the Philadelphia College of Art, renamed the University of the Arts.

She began her career in New York City as a fashion illustrator. Using graceful drawing and charming imagery, she began illustrating children's books, eventually licensing her art and designs to the textile, gift, toy and home decor industries.

With her children, Emily and Dan Silver, nearby, Barbara and Jerry Kalogeratos live on wooded acres in an old farmhouse in Orange County, New York. Barbara enjoys gardening by the wild woods, which offer inspiration and subject matter for her work.

ACKNOWLEDGMENTS

Jane Maday, thank you twice as much as the first time, when you suggested I audition for an art instruction book, which became *Enchanting Fairies*.

Pam Wissman, thank you for this second endorsement, allowing me to explore more fantasy realms.

Thank you to Kelly Messerly, my editor. I don't know how you do it, but I am so glad you've been there—the calm in the center of it all. Thank you very much.

Jerry Kalogeratos, if ever someone embodied the meaning of their last name it's you, Good Older Man of the Mountain. Lucky me.

DEDICATION

This book is dedicated to two of the best teachers of my life, Emily and Dan Silver, my children. You are my dreams come true.

TABLE OF CONTENTS

CHAPTER 1
Elven Faces & Figures
22
Find everything you need to start creating your favorite elven creatures here.

CHAPTER 2
Elven Characters
46
Learn how to create a range of elven folk, from a sweet baby sprite to an elven warrior.

CHAPTER 3
Elven Realms
102
Discover how to bring the world of elves to life.

Introduction

THOUGH LEGENDS, MYTHS AND FANTASIES VARY IN CULTURES AROUND THE GLOBE, ALL SERVE TO INFORM AND GUIDE US IN OUR SHARED HUMAN EXPERIENCES. Whether handed down in oral or written form, images of noble heroes and heroines, playful and mystical creatures become confined to our hearts and imaginations. Pencils, watercolor and paper can help us set these creatures free.

Just as an author (or an artist who must think of herself as an author from time to time) begins with a single word, so must every painter begin with a single stroke of the brush. This can be absolutely terrifying. Yet, it's reassuring to know this feeling is shared by most creatives. My advice is not to proceed with caution. Jump right in, remembering that an author usually does not know at the outset how the story will end, but trusts that well-developed personalities will lead to a successful conclusion. Similarly, trust that by following your heart and setting solid foundations in your paintings using the steps and guidance suggested here, your pictures will have happy endings. Not every time, of course. We're only human but well equipped to try and try again.

Though we share much in common, no two of our stories or paintings are exactly alike. Rejoice in your uniqueness and tell your story in glorious living color.

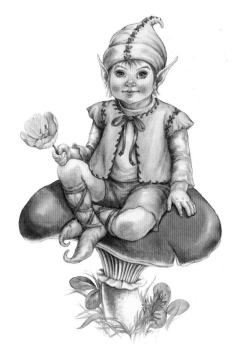

MATERIALS

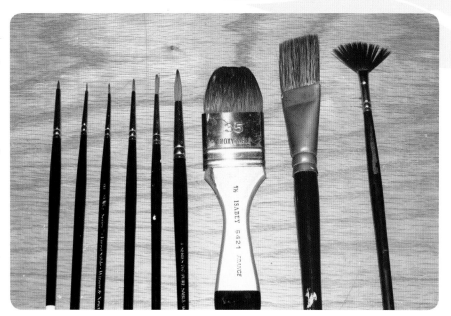

Sable Watercolor Brushes

BRUSHES

Buy sable brushes if you can for watercolors. They are more economical in the long run. The most important characteristic of brushes is how well they hold their points, and you can expect points to last with better brushes. Test them while shopping, as most stores will provide a cup of water. Most of the paintings in this book are 11" × 14" (28cm × 36cm) and, except for the large background washes, do not require large brushes. For background washes, use a 1½-inch (38mm) flat. The Winsor & Newton Series 7 Miniatures are handy for creating fine details. For maximum control, use a no. 2 miniature round. When painting fur, a no. 1 fan brush does a beautiful job. Use a stipple brush to create a mottled effect for backgrounds or to create the texture of leaves. Simply dip the brush in thick pigment, tap it a few times on scrap paper to remove excess pigment and let the remaining pigment dry slightly. Tap the stipple brush up and down to add texture.

PALETTES

For watercolors, circular plastic trays containing ten small wells and one large well in the center allow you to easily mix colors in the center. Use a separate tray for each color group to keep your colors harmonious. Arrange the pigments from warm to cool hues. After any prolonged storage, use an eyedropper or brush to add a bit of water to each well of dried color, bringing back the pigments' creamy consistencies before painting.

Watercolors and Watercolor Palettes
A simple document holder purchased at an office supply store is an easy and convenient way to store your palettes.

MASKING FLUID

Applying masking fluid over foreground elements takes the worry out of creating even background washes. After the fluid dries, it becomes a protective barrier. It can be either white or tinted.

Remove masking fluid using a square masking fluid pickup or your fingertips. Apply the fluid with inexpensive acrylic brushes (or ancient sable ones) dipped in soap.

Before removing masking fluid, make sure that any remaining pigment on it is dry, or better yet, removed carefully with a damp tissue. Otherwise, stray pigment may get on your painting during the removal process.

PAPER

There are so many exciting papers. Art supply stores are the best places to see and feel samples, and sometimes companies will send you free ones. Catalogs show textures as well as possible, but experimentation is the only way to find the paper for you. I've been very happy with 140-lb. (300gsm) Winsor & Newton hot-pressed paper. Its satin finish absorbs well, is a nice bright white and can take lots of abuse.

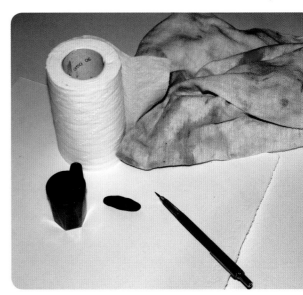

Pencil, Kneaded Eraser, Pencil Sharpener, Paper Towels, Rags and Paper

PENCILS

Have a range of pencils with a soft (B) and medium (HB) lead. Begin your drawing with the softest lead (such as a 2B) because it easily erases away. Use an HB lead once you're happy with your sketch.

PAINT RAGS

Cotton diapers word the best because they're so absorbent. Mine are twenty-six years old, the age of my first child. In the absence thereof, discount stores carry packages of soft rags, or there is always that sentimental T-shirt with which you hate to part. You can also use two-ply bathroom tissue or facial tissue to absorb color where it has pooled.

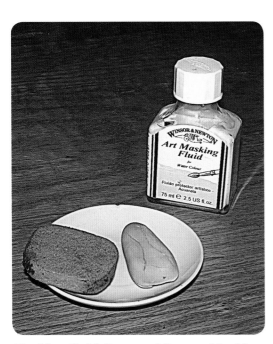

Masking Fluid, Soap and Square Masking Fluid Pickup

COLOR

Learning about color is a lifelong pursuit. Here are some basic facts to get you on your way or to refresh your memory:

Hue is another name for color.

Tint is a color to which white has been added. If you're working in watercolor, you can also add more water to the pigment to lighten.

Shade is a color to which black or gray has been added.

Key color is the dominant color in a picture.

Neutral gray is a mixture of black and white.

Chroma is the brightness or dullness of a color.

Value is the lightness or darkness of a color.

Temperature is the warmness or coolness of a color.

Understanding these basics will help you decide which colors are best suited to the type of fairy you wish to portray. For instance, a quiet, peaceful fairy would wear and be surrounded by serene colors such as cool violets, blues and greens. An assertive fairy would wear and be surrounded by aggressive, passionate colors such as yellows, oranges and reds.

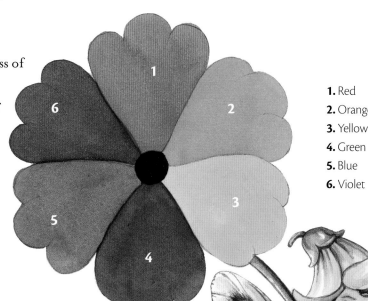

1. Red
2. Orange
3. Yellow
4. Green
5. Blue
6. Violet

The Color Wheel and Color Harmony

The color wheel is a wonderful visual tool for creating color harmony. By just glancing at the color wheel, you can select compatible color schemes that make your fairies nearly fly off the page.

- **Primary colors** are those that cannot be made by mixing other colors. They are yellow, red and blue.
- **Secondary colors** are created by mixing primary colors. They are orange, green and violet.
- **Tertiary colors** are those made by mixing primary colors with a secondary color. Red and orange become red-orange, yellow and orange become yellow-orange.
- **Complementary colors** are colors opposite one another on the color wheel. Red and green are complements, as are blue and orange and yellow and violet.

PAINTS

Facing the many tempting watercolors available, many artists are like kids in a candy shop. When selecting colors for the demonstrations in this book, I was no exception. However, it isn't necessary to buy all the colors I used. I've made one exception by adding Chinese Orange, a gouache, which I use for its vibrancy.

Begin your selection with the primary colors of Cadmium Yellow, Cadmium Red and Cobalt Blue. Then, with the addition of transparent colors such as New Gamboge, Alizarin Crimson, Permanent Sap Green and Indigo you can mix colors that are close to these.

Ivory Black and Chinese White are important, too. For highlights, have on hand Designer's Gouache in White or another opaque white.

Beyond these, select colors that suit your personality. Read the labels and be careful to avoid getting certain pigments on your skin or putting your brush in your mouth. Also, replace your rinsing water often so your colors perform their best. Don't forget to stop and clean unwanted color from your palette, too. If you've mixed one color into the pan of another, lift it out with your paint rag or sponge leaving only bright pigment behind.

Full Palette of Watercolors

This is just an example of the color options available to you.

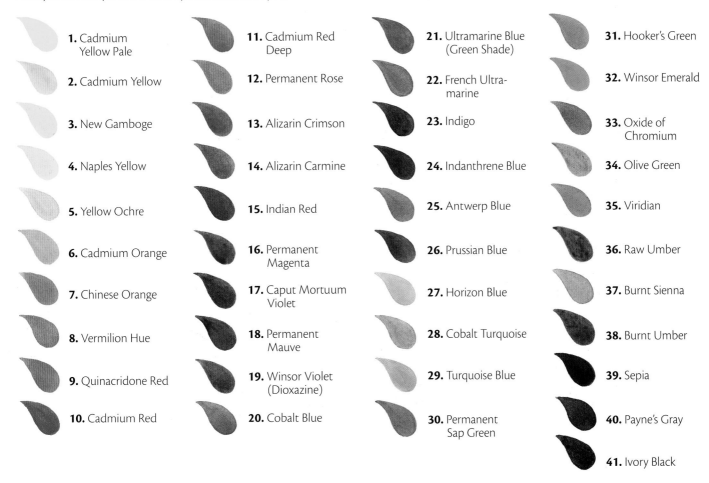

1. Cadmium Yellow Pale
2. Cadmium Yellow
3. New Gamboge
4. Naples Yellow
5. Yellow Ochre
6. Cadmium Orange
7. Chinese Orange
8. Vermilion Hue
9. Quinacridone Red
10. Cadmium Red

11. Cadmium Red Deep
12. Permanent Rose
13. Alizarin Crimson
14. Alizarin Carmine
15. Indian Red
16. Permanent Magenta
17. Caput Mortuum Violet
18. Permanent Mauve
19. Winsor Violet (Dioxazine)
20. Cobalt Blue

21. Ultramarine Blue (Green Shade)
22. French Ultramarine
23. Indigo
24. Indanthrene Blue
25. Antwerp Blue
26. Prussian Blue
27. Horizon Blue
28. Cobalt Turquoise
29. Turquoise Blue
30. Permanent Sap Green

31. Hooker's Green
32. Winsor Emerald
33. Oxide of Chromium
34. Olive Green
35. Viridian
36. Raw Umber
37. Burnt Sienna
38. Burnt Umber
39. Sepia
40. Payne's Gray
41. Ivory Black

GETTING STARTED

Unless you're using a heavyweight water-color paper 300-lb. (640gsm) or heavier, you'll need to stretch the paper or it will buckle when you apply watercolor washes. Stretching watercolor paper is easy—just anchor the paper down, wet it, and wait for it to dry flat.

Tape down the paper with blue painter's tape, found in most hardware and art supply stores, since it won't tear the paper when you remove it. Use a flat wash brush to apply the water. Remove excess water with a sponge or a dry brush and let the paper dry.

~YOU WILL NEED~

MATERIALS

1½-inch (38mm) sable flat brush ∞ Blue tape ∞ Hair dryer ∞ Watercolor paper ∞ Watercolor paper block backing or other firm surface

STRETCHING WATERCOLOR PAPER

1 Secure your watercolor paper to a firm backing with the blue painter's tape.

2 Using a 1½-inch (38mm) flat, apply water horizontally, then vertically to the paper.

3 Let the paper dry naturally or use a hair dryer set at medium heat.

SPEED UP THE DRYING TIME

If you don't want to wait for your watercolor paper to dry, use a hair dryer to make that paper dry faster!

To transfer a drawing to your watercolor paper, make a photocopy of the image and enlarge it to your preferred size. Trace the enlarged image onto tracing paper and transfer it to your watercolor paper using graphite or blue Saral transfer paper. I prefer blue because it lifts more easily when erased and does not reproduce for printing purposes. If the blue or graphite lines are too heavy, press a kneaded eraser on them to remove the excess graphite.

TRACING AND TRANSFERRING AN IMAGE

1 Once you have traced the drawing onto your tracing paper, tape the tracing paper to the top of your watercolor paper. Place your transfer paper facedown between your tracing paper and your watercolor paper.

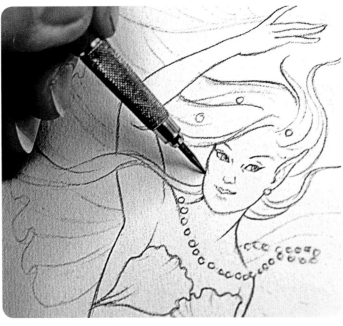

2 Using a hard-leaded pencil or a ballpoint pen that has run out of ink, go over the lines of your tracing, transfering your image to the watercolor paper beneath it.

3 Use an HB pencil to carefully redraw and fill in the image. Try not to lose the spontaneity of the original drawing. This is the time to add details to your subjects.

USING COLOR TO CREATE LIGHT AND SHADOW

Painting the effects of light on your subjects will bring them to life. Light and shadow depend on the time of day and the direction of the light. If your subject is sitting outside in the middle of the day, the contrast between light and shadow will be much stronger than if it was sitting in late afternoon light where there would be less contrast between the lights and shadows.

Regardless of the time of day, any lit object should have the following elements:

Highlight: The area where the light hits most directly. This is usually bright white.

Reflected light: The light bounced back onto the object from the surface it rests on.

Cast shadow: The shadow cast from one object onto another.

Form shadow: The areas where light does not hit the object. The coolest, darkest part of the form shadow is the *core shadow*.

Think of the core shadow as the opposite of the highlight.

When light falls directly on a subject, it creates *hard-edged* shadows, or very distinct changes from the light to the shadow. When the light is obstructed, it will create *soft-edged* shadows where the transition between light and shadow is more blended and gradual.

Capturing the Effects of Light and Shadow
- **Highlight** is the light directly hitting the cherry's surface.
- The **reflected light** is the pinkish color on the cherry where the light of the surface hits it.
- The **cast shadow** falls behind the cherry onto the surface. Notice that it's a violet color and not a dull gray.
- The **form shadow** is along the sides of the cherry that aren't directly in the light.
- The **core shadow** is the darkest area of the shadow on the surface.

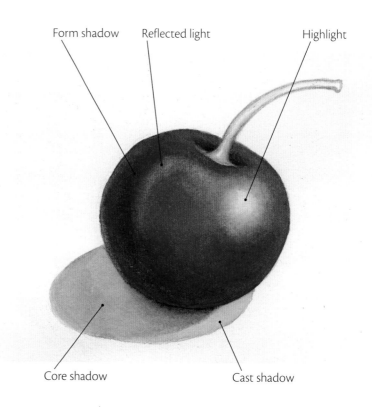

Form shadow Reflected light Highlight

Core shadow Cast shadow

A color's hue, value and temperature can be used to create light with such techniques as creating tints and shades of a color. Light tints can be used to suggest the lighter areas while dark shades fill out the areas in shadow.

⤳ YOU WILL NEED ⤳

PAINTS
Ivory Black ⤳ Winsor Violet (Dioxazine)

MATERIALS
No. 1 sable round brush ⤳ Palette ⤳ Stretched watercolor paper

CREATING TINTS

1 Mix equal parts of Winsor Violet (Dioxazine) with water and apply this to your surface.

2 Add a bit of the same color to another palette well or another area of the paper. This time, mix in more water to create a lighter tint.

3 Add even more water to the original color to create a very light tint. The possibilities are endless and allow you to create dynamic shadows.

CREATING A SHADE

1 In a palette well or on your paper, mix Winsor Violet (Dioxazine) with a very small amount of Ivory Black and enough water to create a creamy consistency. This creates a very dark shade of the color, perfect for a night sky.

2 Place a bit of the original color in another palette well and add an equal amount of water to create a medium shade.

3 Place a bit of the medium shade into a third palette well and add an equal amount of water to create a light shade.

APPLYING A WASH

One of the most daunting challenges in every watercolor artist's career is learning to apply even washes. However, once the steps are broken down, the mystery is gone. The basic rules, which should not be broken, are as follows:

1. Wait until the shine is gone from your wet surface before applying color.
2. Have enough pigment mixed to cover the intended area; letting the pigment on the paper dry while you mix more pigment will lead to poor results.
3. Direct the flow of your wash by tilting your paper back and forth in all directions.

Take a deep breath (without holding it), throw caution to the wind and begin.

You can create many different kinds of washes for a variety of dynamic backgrounds, from a simple flat wash, in which the background is an even color, to a gradated wash, in which the background gradually changes from dark to light. We'll start with a gradated wash, which you'll use often in the demonstrations to come.

~❀ YOU WILL NEED ❀~

PAINTS

Cerulean Blue ❧ Lemon Yellow

MATERIALS

1½-inch (38mm) sable flat brush ❧ Stretched watercolor paper

CREATING A GRADED WASH

1 With a 1½-inch (38mm) flat, wet the entire sky area and apply Lemon Yellow at the bottom of the paper. Tilt your board upside down and back and forth to allow the color to fade into the clear water. On your palette, prepare three different tints of Cerulean Blue by adding increasing amounts of water.

2 Apply the lightest tint of Cerulean Blue about one-fourth of the way up the paper where the yellow has faded away. Apply the pigment by brushing back and forth. Add a medium tint of Cerulean Blue above the light tint, working as quickly as possible and tilting the board side to side and back and forth.

3 Above the medium tint, add the darkest tint of Cerulean Blue. Turn your board upside down and left to right, allowing the two colors to blend together for even coverage.

WORKING WET-INTO-WET

As the term suggests, wet-into-wet is the practice of adding pigment into a painted area that is still wet so the colors will merge. This technique is employed in most watercolor paintings.

Whether you are painting a sprite's wings, a dress or a flower petal, this technique can suggest reflected light. Use the wet-into-wet technique for small detailed areas of your painting or to create interesting background washes.

~ YOU WILL NEED ~

PAINTS
Cobalt Blue ~ Winsor Violet (Dioxazine)

MATERIALS
1½-inch (38mm) sable flat brush ~ No. 8 sable round ~ Stretched watercolor paper

THE WET-INTO-WET METHOD

1 Wet the area you intend to paint with a 1½-inch (38mm) flat. When the sheen has gone, you're ready to add your first color. Working quickly, apply some Cobalt Blue with a no. 8 round. Notice how the paper's wetness creates soft edges.

2 Before the first layer dries, add Winsor Violet (Dioxazine) with the no. 8 round. Tilt your board from left to right to allow the colors to blend softly and seamlessly.

CHARGING COLORS

Charging, or adding colors to an area of paper that is still wet, allows your colors to mingle, creating the subtle blend of light and shadow that happens in nature.

~ YOU WILL NEED ~

PAINTS
Cadmium Red ⌁ New Gamboge ⌁ Permanent Sap Green ⌁ Yellow Ochre

MATERIALS
HB lead pencil ⌁ No. 1 sable round brush ⌁ Stretched watercolor paper

CHARGING SEVERAL COLORS

1 Draw or transfer your leaf onto stretched watercolor paper. Using an HB lead, redraw the basic leaf shape.

On your palette, thin New Gamboge, Yellow Ochre, Cadmium Red and Permanent Sap Green to a creamy consistency.

2 Wet the entire leaf and let it dry briefly. Using a no. 1 round loaded with New Gamboge, paint the left side of the leaf. Tilt your surface so the color drifts into the clean wet space.

3 Working quickly, clean your brush and repeat the procedure with Yellow Ochre on the opposite side of the leaf.

4 Follow the procedure for Step 2, using Permanent Sap Green and applying it to the leaf's top and bottom. Then apply Cadmium Red to the lower right. Tilt your board so the colors blend. Charge in darker tints to create shadows and let dry.

5 From here you can layer in veins and other details to complete the leaf.

USING MASKING FLUID

Masking fluid takes the headache out of painting large, loose background washes by creating a barrier over detailed foreground objects.

Use durable and inexpensive brushes to apply masking fluid, such as student-grade Winsor & Newton University acrylic brushes. Before you load your brush with masking fluid, dip it in water, then rub it on a wet bar of soap. This makes cleanup easier and extends the life of the brush.

If you are applying masking to very fine objects, thin the masking fluid with water. If the foreground objects have less detail, you might not need to mask at all.

REMOVING MASKING FLUID

Sometimes the masking peels right off by rubbing it with your fingertips. If not, use a square masking fluid pickup, or you can roll dry masking into a ball for a homemade pickup.

USING MASKING FLUID

1 Trace your drawing onto stretched watercolor paper.

2 Apply the masking fluid along the edges of the image with a no. 1 acrylic round dipped in water and rubbed on a wet bar of soap.

3 Apply your background treatment, in this case a wash. When the background is completely dry, blot any color that has pooled on top of the mask with facial tissue and carefully remove the masking fluid.

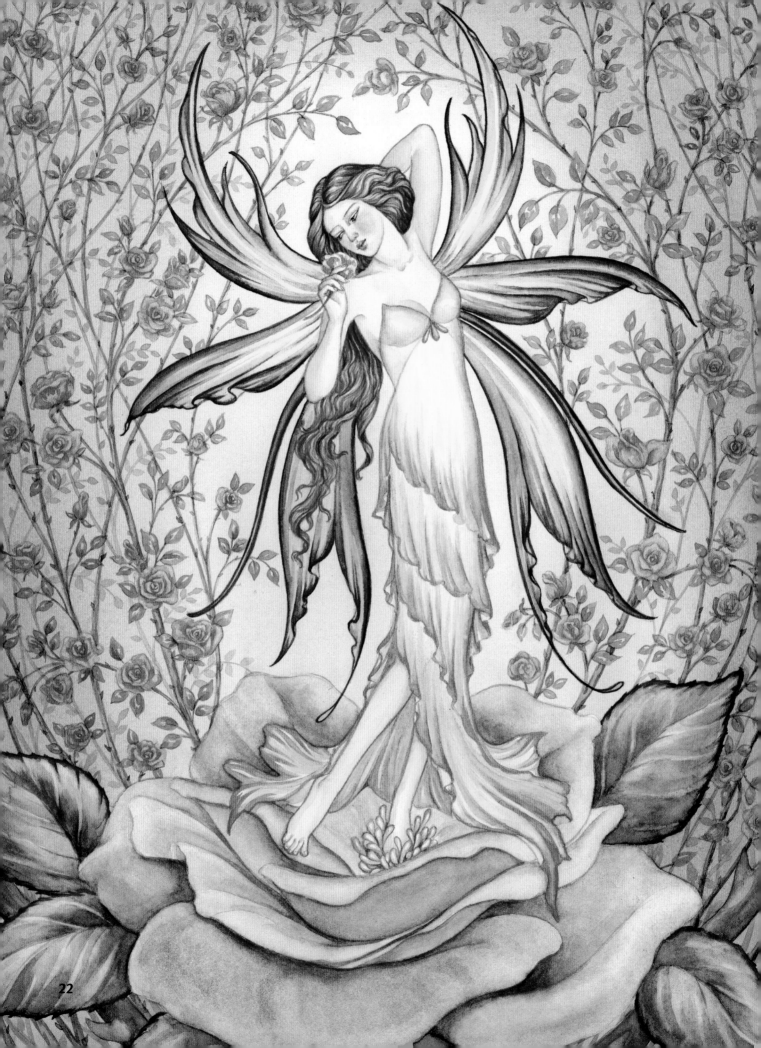

ELVEN FACES & FIGURES

To GATHER INSPIRATION FOR THE FACES OF ELVES YOU NEEDN'T GO FARTHER THAN YOUR OWN BACKYARD. Family and friends may be just what you need. What distinguishes elves from people you know, however, is the far-away look in their eyes. The gaze of an elf is steady and direct and comes from distant worlds unlike any we have seen. The shape of the head of a child elf is very similar to that of children you know, yet the eyes of elven children seem older than their years. The same is true of adult elves. In this section you will study the proportions of the heads of an elven child and adult female and male elves.

ELF FACE, FRONT VIEW

Practice drawing the female elf face first, as this will outline the basic process for drawing elven faces. Use this process for drawing the male and baby elf faces, noting their differences in the steps below.

MINI DEMONSTRATION — *Female Elf*

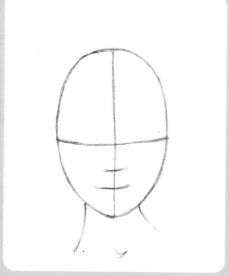

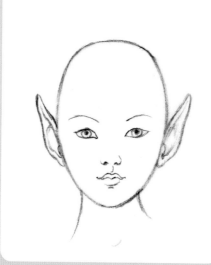

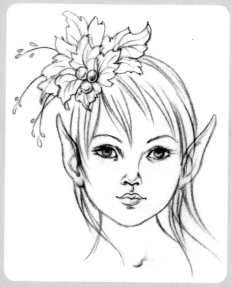

1 Using an HB lead pencil, draw an oval that's wider in the middle and pointed at the bottom. Draw a vertical line down the center and a horizontal line halfway down the vertical line. At one-third the distance between the eyes and the chin, add a horizontal line then another below it. Indicate the neck and collarbone center.

2 To create a dreamy look, draw slightly almond-shaped eyes, adding a partial circle for the iris. Draw the eyebrows in graceful arcs. Indicate nostril openings by drawing tiny ovals and small arcs at the outer edge of each oval. Indicate the lips with a curved line then fill in the rest. Draw pointy ears with the earlobe lining up with the bottom of the nose.

3 Add eyelids, then add creases to the inner eye corners. Place a stroke from the inner eye corner down the length of the nose and indicate a curve at the tip. Place pupils near the upper eyelids and shade. Draw a bold line around each eye. Add shading to the lips. Sketch the outline of the hair in wispy strands and add an exotic flower.

SHAPE MATTERS

Typically, a female elf's head begins with a graceful oval that narrows at the bottom. An elven child's face is more rounded at the sides, with the eyes placed in the middle of the oval. The oval of the male elf face is straight at the sides with sharp angles for the jaw and chin.

MINI DEMONSTRATION ~ *Male Elf*

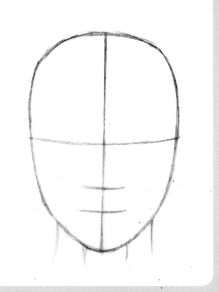

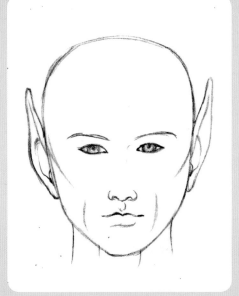

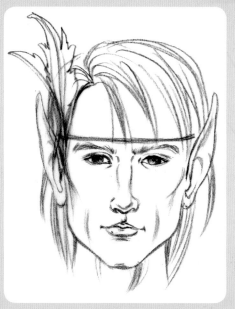

1 Using the same basic technqiue you used in Step 1 for the female elf, draw the sides of the oval, jaw and chin lines. Make the sides of the oval much straighter than the female face.

2 Sketch in the eyes, eyebrows, nose and lips. Eyes that are deep-set with straight brows close to the eyes add to the masculine appearance. Add arcs on each side of the mouth, lines to indicate an Adam's apple and thin lips.

3 Fill in the features, including adding a squarish hairline and thick brows. Emphasize the lower lip and refine nose and eyes.

MINI DEMONSTRATION ~ *Baby Elf*

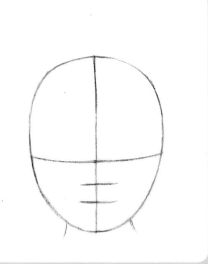

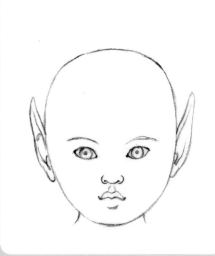

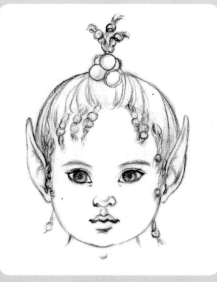

1 Draw a full, rounded oval. Curve lines outward to indicate a short neck.

2 Draw eyes close to the center line. Add an iris that takes up most of the eye. Extend each eyebrow past the eye's width. Shade the upper and lower lips and add an indentation above the top lip. Begin ears at the nose, curving them up and out beyond the eyebrows.

3 Add upper eyelids and darken the brows. Add lines below the inner eye corners to indicate lower lids. Add a faint arc to indicate the nose. Curve the hair toward the center of the head. Add hair to the forehead, sides, and behind the ears. Draw in small braids and beads.

ELF FACE, 3/4 VIEW

Let's use the female face again as the standard by which we compare the characteristics of the male and child elf faces. Look at Step I of each demo and not the different oval shapes. The female oval tapers more than the others. The male oval is narrower, longer and less pointed at the bottom. The child's oval is wider and not as pointed.

MINI DEMONSTRATION ～ *Female Elf*

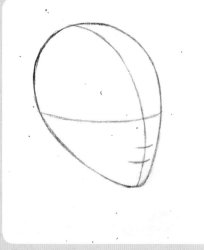 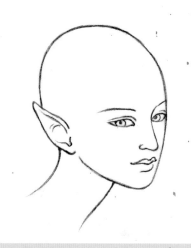 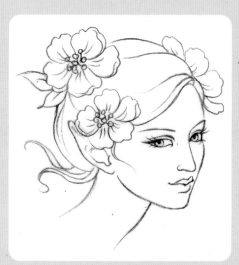

1 Draw an oval wider at the middle, narrow at the bottom and tilted to the left. One-sixth of the way from the left side of the oval, draw a rounded vertical line from the top of the head to the chin. Halfway down the vertical line, draw a horizontal line for the eyes. Halfway between the eye line and the chin draw a horizontal line for the nose. Below that, draw a line for the mouth.

2 Above the eye line, add a line for the brow and line of the nose. Draw the eye tapering to the left and eyelashes for the right eye. Add upper and lower lips and round out the chin. Draw the ear below the line of the eyebrow, curving the line upward and outward then down and back to the jaw. Draw a graceful curve for the back and front of the neck.

3 Thicken the outline of the eye. Add eyelashes in a few strokes to the left eye. Leave a space between the earlobe and jawline to show where the jaw ends. Add wispy strokes for the hair and flowers on the top and sides of the head. Draw wavy wisps on the forehead and the nape of the neck.

MINI DEMONSTRATION — *Male Elf*

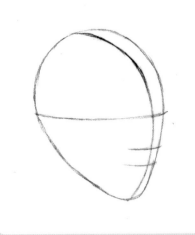

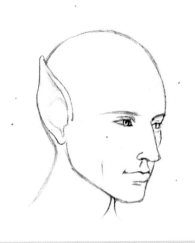

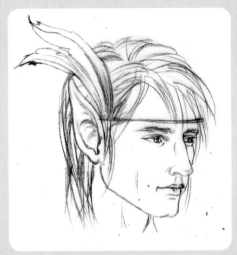

1 Draw an oval that's longer and narrower than the female oval. Make sure the chin area is more square than pointed.

2 Draw deep-set eyes by placing the brows closer to them. Begin at the center line and draw the line of the nose and nostril. Indicate the mouth with a wavy line for the top lip and make the bottom lip more full. Indicate the top of the chin with a short line just below the lower lip. Square the jawline and shape the right cheek. Indicate the Adam's apple by a curved line.

3 Shape the eyes and use short strokes to thicken the brows. Add a curved line to the side of the nose and another at the nostril tip. Shade the lips and corners of the mouth. Darken the vertical line indicating the cheek hollow. Add a round cleft and another line to the side of the Adam's apple. Curve the hair from the center of the head down the sides, behind the ears and nape. Add a feathered band above the brow.

MINI DEMONSTRATION — *Child Elf*

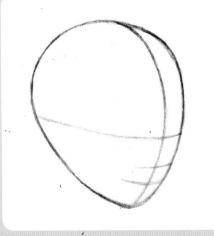

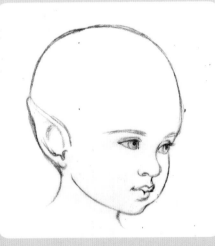

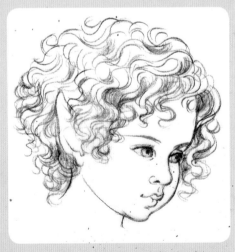

1 Using an HB lead pencil, draw an oval wider at the top and sides than the narrow female face. Near the right side, draw a rounded vertical line from the top of the head to the chin. Add a horizontal eye line just below the center of the head. Place a line for the nose between the eyes and the chin. Add a line for the mouth below the nose.

2 Space the eyes farther apart than an adult's. Use short strokes to add the eyebrows. Add the nose with a curved line beginning at the right eye's inner corner and ending it at the center line. Add the left nostril and the lips. Add curving arcs to indicate the neck. Start the ear just below the eye line.

3 Draw an indentation on the left side of the nose. To indicate the lower lid, add a short line at the left eye's inner corner. Draw another line above the upper lip and add more shape to the left side of the chin. Draw hair in wavy lines beginning at the upper right of head. Add curly tendrils on the brow and nape of the neck.

DRAWING A WOODLAND ELF

This woodland elf must not be hindered in the forest by elaborate clothing; yet his garb should reflect his character and rank. His confident grasp on the standard bearing the blue of his tribe and his steady gaze give him a regal air. By drawing accurate folds and textures in his attire you'll make his appearance more believeable.

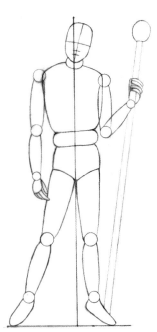

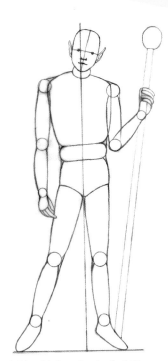

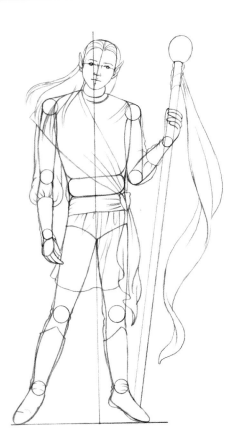

1 Draw a horizontal line 6 inches (15cm) in length. At the center, draw a vertical line about 12 inches (30cm) high. Starting at the bottom of the vertical line, measure and mark every 1¾ inches (14mm) until you reach the top. This gives you about seven head lengths. Draw the head following Step 1 at the top of page 25.

2 Add guidelines for the facial features, as you did on pages 24–25. Build the body with ovals and circles of various sizes. Use larger shapes for larger areas of the body such as the chest, belly and thighs. Use smaller shapes for smaller areas such as the neck, arms and elbow joints.

Connect these joints with long ovals. Draw smaller circles for the wrists and connect the elbows to the wrists with long ovals. Draw irregular ovals for the palms of the hands and add thin ovals for the fingers. Add a staff leading from the middle of the foot past his hand to a round gemstone at the top.

3 Connect the circles and ovals with a solid line along the outer edge of the figure. Draw the tunic, sashes, leggings and boots. Since the hip on the right is thrust to the right, make sure the folds radiate from that point. Continue fleshing out the facial features.

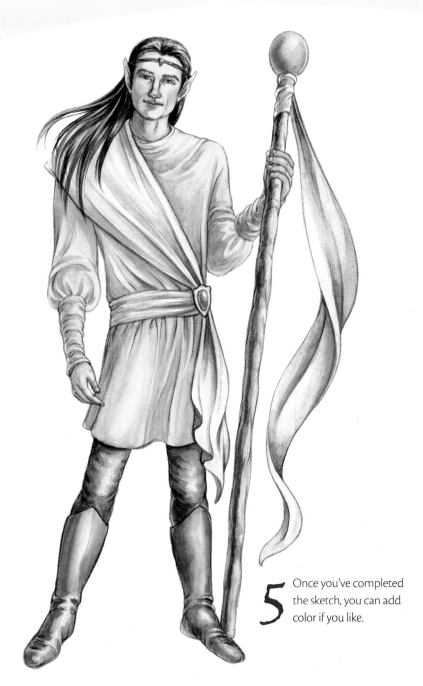

4 At this point you can refine your drawing on a tracing paper overlay, or, if you prefer, you can lift a lot of the graphite with a kneaded eraser and continue drawing on the same paper. Detail the facial features and refine his figure and outfit. Transfer your drawing using transfer paper.

5 Once you've completed the sketch, you can add color if you like.

DRAWING A SPRITE

*Because her legs are crossed, the pose of our Blue Sprite may seem
complicated until you see it broken down into ovals and circles. Note
the slender proportions and playful gesture suggesting a sprite personality.
Her pose suggests she is flitting from flower to flower.*

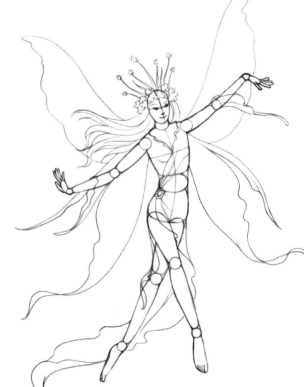

1 Begin with the head, adding
guidelines for the facial features
as you did on page 26. Work
your way down through the torso, waist
and hips with ovals and circles of various
sizes. Drawing an arc from the neck
through the hips as a guide will help
give the body movement.

Start on the the legs and feet, using
larger ovals for the thighs and calves,
and small circles for the joints. Since the
upper leg is raised it is foreshortened.
Draw irregular ovals for the feet.

Continue with circles and ovals for
the shoulders, arms and wrists. Draw
irregular ovals for the palms of the
hands and slender ovals for the fingers.

2 Draw a solid line connect-
ing all the outer lines of the
circles and ovals to flesh out
the figure.

Start defining facial features.
Indicate the eyes by drawing tiny
circles. Draw the bottom of the
nose and add a line for where the
lips meet.

3 Now it's time to add hair, wings and flowing
clothing to our Blue Sprite. Since she is mov-
ing to the right, her hair and clothing will trail
to the left. Let the wings and clothing ripple to show
how weightless they are. Add a headdress made of
delicate flowers.

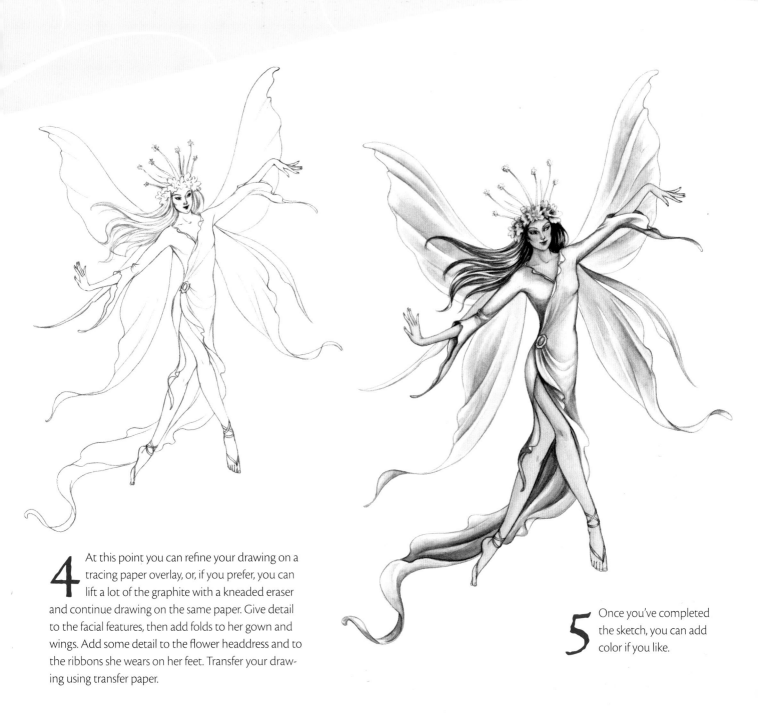

4 At this point you can refine your drawing on a tracing paper overlay, or, if you prefer, you can lift a lot of the graphite with a kneaded eraser and continue drawing on the same paper. Give detail to the facial features, then add folds to her gown and wings. Add some detail to the flower headdress and to the ribbons she wears on her feet. Transfer your drawing using transfer paper.

5 Once you've completed the sketch, you can add color if you like.

DRAWING A GNOME

*Gnomes all around the globe are similar in shape. Their
proportions and playful personalities suggest those of young
children. Study these basic shapes and apply them when
drawing gnomes engaged in various activities. For our gnome I've
chosen traditional clothing colors.*

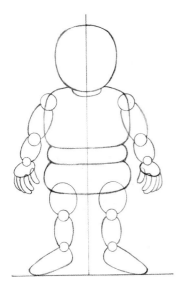

1 Build the body with ovals and
circles of various sizes. Use larger
shapes for larger areas of the body
such as the chest, belly and hips. Use
smaller shapes for smaller areas such as the
neck, arms, legs and joints.

Draw smaller circles for the ankles with
wedge-shaped ovals for the feet. Draw
smaller circles for the wrists, and irregular
ovals for the palms. Last, draw curved nar-
row ovals for the fingers.

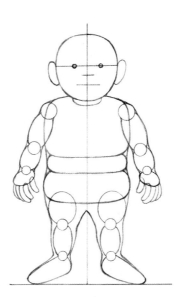

2 Add guidelines for the facial features,
as you did on pages 24–25. Draw
small ovals for ears on each side of
the head, beginning each oval at eye level.

Draw a line to connect all the ovals and
circles on the outside to flesh out the figure.

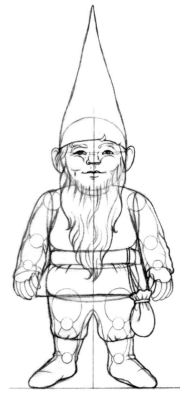

3 Now add some details to your
gnome. Give shape to the eyes.
Add round cheeks and a nose, and
upturned lips to form a smile.

Draw soft waves for his beard and add
ears, cap, shirt, belt, legs, boots and pouch.

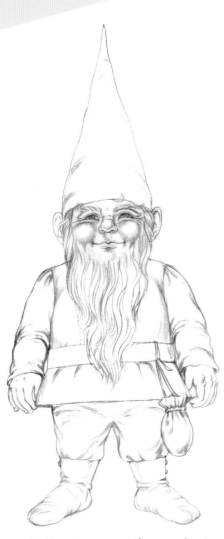

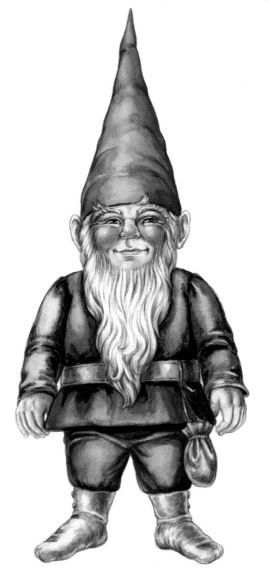

4 At this point you can refine your drawing on a tracing paper overlay, or you can lift a lot of the graphite with a kneaded eraser and continue drawing on the same paper. Give interest to your drawing by adding creases in his sleeves, pants and boots. Transfer your drawing using transfer paper and a ballpoint pen that is out of ink.

5 Once you've completed the sketch, you can add color if you like.

DRAWING A DWARF

When drawing dwarves, it is important to show how strong they are. Their massive, wide heads, large hands and barrel chests are their most distinc-tive features. The proportions suggested here will help you when creating other poses for your dwarves. Popular coloring is a ruddy skintone with auburn hair, but other colors and tones are just as suitable.

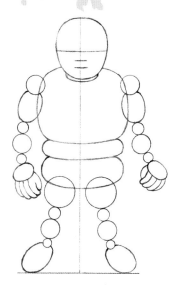

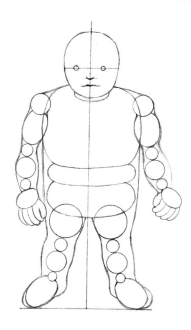

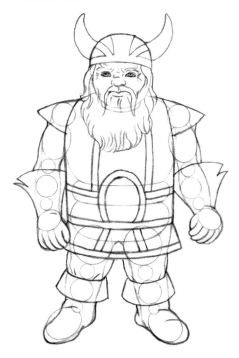

1 Build the body with ovals and circles of various sizes. Use larger shapes for larger areas of the body such as the chest, belly and hips. Use smaller shapes for smaller areas such as the neck, arms, legs and joints.

Note that the arms and legs of a dwarf are made up mostly of circles. Draw the arm on the left turned toward the body and the arm on the right turned outward. Add ovals for the palms and thinner, curved ovals for fingers.

Draw guidelines for the facial features, as you did on pages 25.

2 Draw circles for the eyes and a U-shape for the bottom of the nose. Then, draw a bow-shaped line for the center of the mouth. Draw a connecting pencil line along the outside of the circles and ovals to flesh out the figure.

3 Give your figure lifelike detail beginning with the eyes. Draw almond shapes and pupils partly hidden by the upper eyelids. Draw the bridge of the nose, the ball-shaped end of it and the nostrils.

Draw the eyebrows in short, curved lines giving them a pronounced arch. Draw his cheeks and mouth, then draw his long mustache which falls halfway down his beard. Next, draw the wavy hair at the sides of his head flowing down to his long beard.

Draw his helmet, armor, gloves, pants and boots.

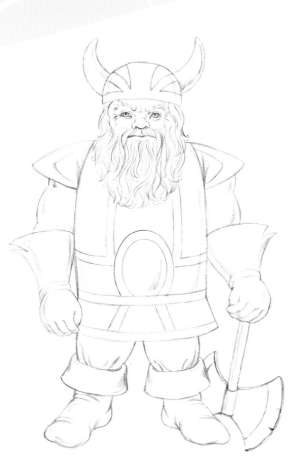

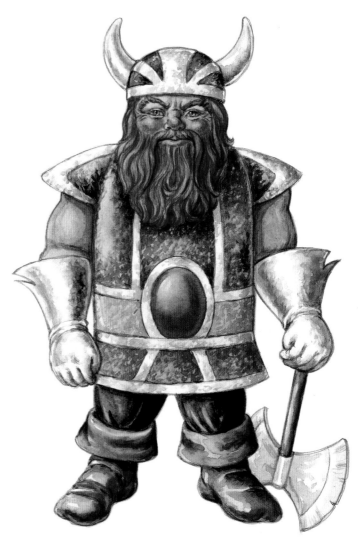

4 At this point you can refine your drawing on a tracing paper overlay, or you can lift a lot of the graphite with a kneaded eraser and continue drawing on the same paper.

Give interest to your drawing with extra details. Add creases in the dwarf's face and clothing to give expression and form. Define his arm muscles to show strength. Draw the ax, tilting the handle inward. The ax blades are made up of curved lines. Be sure to show the thickness of the blade by adding a similar line behind the first. Next, draw shading on the horns of the helmet, creases at the shoulders, gloves, muscles and center oval of his armor. Transfer your drawing using transfer paper and a ballpoint pen that is out of ink.

5 Once you've completed the sketch, you can add color if you like.

PAINTING A CHRISTMAS ELF

This little fellow is the type of elf most often seen helping Santa. Note his smaller proportions and exaggerated gesture.

~YOU WILL NEED~

PAINTS

Burnt Sienna ✺ Cadmium Red ✺ Indigo ✺ Lamp Black ✺ New Gamboge ✺ Olive Green ✺ Permanent Sap Green ✺ Quinacridone Red ✺ Raw Umber ✺ Turquoise ✺ Winsor Violet (Dioxazine)

MATERIALS

HB lead pencil ✺ Nos. 000, 00, 0 and 1 sable round brushes ✺ Stretched watercolor paper ✺ Transferring materials from page 15

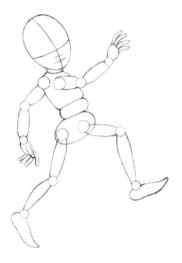

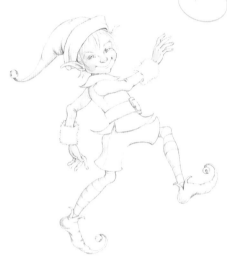

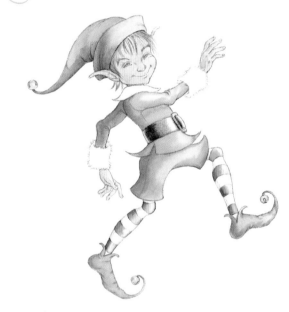

1 Draw circles for the hips and long ovals for the thighs, smaller circles for the knees and ovals for the lower legs. Draw smaller circles for the ankles and pointed ovals for the feet.

2 Flesh out the features then draw a connecting line along the outside edge of the circles and ovals. Transfer the drawing to the watercolor paper.

Mix Raw Umber with Olive Green and apply a light tint of this to the shadows on his face and hands with a no. 1 round. Clean the brush and use it to apply a light tint of Winsor Violet (Dioxazine) to the shadow areas of the hat, jacket and shorts. With a no. 0 round, apply a light tint of Indigo to the back of the leggings. Clean the brush then apply a light tint of Turquoise to the cuffs.

3 With a no. 1 round, apply clean water to the cap. Let this dry briefly then apply a medium tint of Permanent Sap Green. Let this dry briefly then apply a deeper tint of the green to the elf's back. Repeat this on the jacket, pants and shoes. Apply water to the face, ears and hands then apply a mixture of Burnt Sienna and Cadmium Red with the no. 1 round. Wet two stripes of the leggings at a time and apply Quinacridone Red to the back, then blend with clear water to the front. Apply a medium tint of New Gamboge to the bells and buckle with a no. 00 round then add a medium tint of Burnt Sienna to the hair. Wet the belt and apply a light tint of Lamp Black with a no. 1 round. Add another layer of Lamp Black to the belt's back. Paint the irises a medium tint of Permanent Sap Green with a no. 000 round.

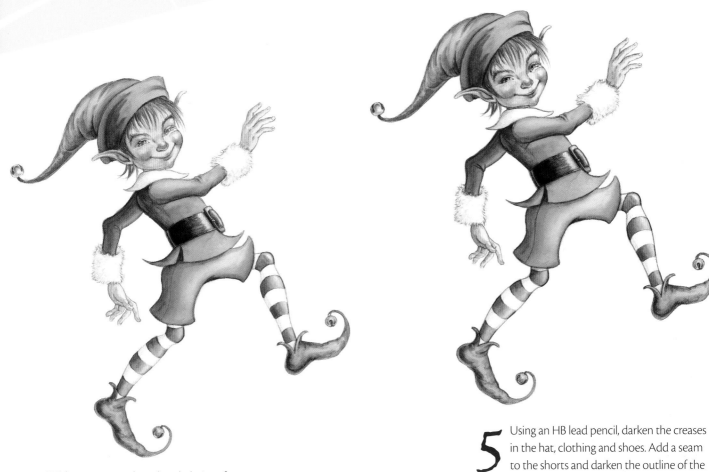

4 With a no. 0 round, apply a dark tint of Permanent Sap Green to the bottom of the right sleeve and to the shadow side of the cap. Do the same to the back of the jacket and the shoes' bottoms. Using a no. 000 round, add tiny strokes of Turquoise to the fluffy cuffs.

5 Using an HB lead pencil, darken the creases in the hat, clothing and shoes. Add a seam to the shorts and darken the outline of the buckle, bells, leggings, face, ears and hands.

PAINTING A SPRITE

This sprite is dancing when something catches her attention. She looks back, swinging her hair in the process. The angle of her bent leg, the arm on the left and the flow of her wings suggest that she will continue to move to the right. Shading also indicates that she is dancing toward the light.

～YOU WILL NEED～

PAINTS

Bright Red ～ Burnt Sienna ～ Burnt Umber ～ Cadmium Orange ～ Cadmium Red ～ Cadmium Yellow ～ Cadmium Yellow Pale ～ Caput Mortuum Violet ～ French Ultramarine Blue • Olive Green ～ Permanent Sap Green ～ Quinacridone Red ～ Winsor Violet (Dioxazine)

MATERIALS

HB lead pencil ～ Nos. 000, 00, 0 and 1 sable round brushes ～ Stretched watercolor paper ～ Transferring materials from page 15

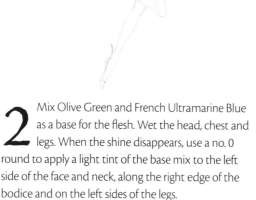

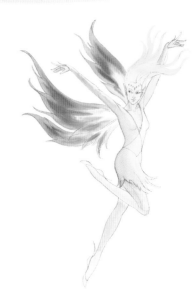

1 Sketch out the sprite with an HB lead pencil then transfer the drawing to stretched watercolor paper using transfer paper and a ballpoint pen that is out of ink.

2 Mix Olive Green and French Ultramarine Blue as a base for the flesh. Wet the head, chest and legs. When the shine disappears, use a no. 0 round to apply a light tint of the base mix to the left side of the face and neck, along the right edge of the bodice and on the left sides of the legs.

Wet the hair and when the shine disappears, use a no. 0 round to apply a medium tint of Cadmium Yellow. Apply this yellow to the outer edges of the wings and back of her torso, blending inward with clear water. Apply the yellow to her slippers with a no. 00 round. With a no. 0 round, apply Cadmium Yellow Pale on the front of her bodice, blending inward with clean water.

3 Mix a bit of Cadmium Red with Burnt Umber for a fleshtone. Wet the flesh areas and when the shine disappears, use a no. 1 round to apply the mixture. Let this dry.

Use a no. 0 round to apply Permanent Sap Green to the left side of the dress and let dry. Wet the wings one section at a time. When the shine is gone use a no. 1 round to apply a medium tint of Cadmium Yellow to the outer edge of the wings. As the shine disappears, apply Bright Red away from the outer edge in zigzag shapes following the shape of the wings. Let dry. Rewet the wings, and, when the shine is gone, apply a medium tint of Cadmium Yellow to the parts of the wings closer to the body.

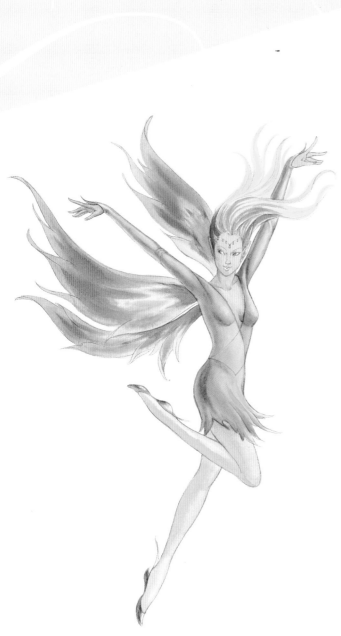

5 Wet the pupils of the eyes and apply Permanent Sap Green with a no. 000 round. Use a no. 00 round to apply a dark tint of Burnt Sienna to the left side of the hair and to the hair flowing to the side. While this is wet, apply Caput Mortuum Violet with a no. 00 round to the darkest areas of the hair.

Using a no. 00 round, apply a light tint of Winsor Violet (Dioxazine) to the areas of skin in shadow. Wet the cheeks and use a no. 000 round to apply a medium tint of Quinacridone Red, blending outward with plain water. Let dry and apply a light tint of the fleshtone mix from Step 3 to all skin areas with a no. 1 round. Let this dry.

Use a no. 000 round to apply a dark shade of Quinacridone Red to her lips, and to apply a dark shade of Bright Red where wispy parts of the wings fold. Add pencil lines to emphasize hair strands, eyes, limbs, wings and folds of her dress. Use a no. 000 round to apply Cadmium Orange to her headdress and Quinacridone Red to the beads.

4 Wet the dress with a no. 1 round then brush on Cadmium Yellow. Let this dry briefly then apply a dark shade of Permanent Sap Green to areas of the dress in shadow. Use a no. 00 round to apply streaks of a medium tint of Burnt Sienna halfway up the hair. Add a darker tint of Bright Red to the previously applied red, keeping it within the zigzag shapes. Use a no. 000 round to apply Permanent Sap Green on the outer edge of the dress, covering the pencil line. Use a no. 0 round to apply Cadmium Orange to the shaded parts of the hair.

PAINTING A GNOME

Here we have the rest of the gnome family from pages 32—33, mother and child. I thought you might like the subject matter so much that you wouldn't mind a more complex drawing, and you'd enjoy learning how to paint the colorful clothing.

~YOU WILL NEED~

PAINTS

Alizarin Crimson ⚘ Burnt Sienna ⚘ Cadmium Orange ⚘ Cadmium Yellow ⚘ Caput Mortuum Violet ⚘ Chinese White ⚘ Cobalt Turquoise ⚘ Indigo ⚘ Olive Green ⚘ Payne's Gray ⚘ Quinacridone Red ⚘ Sepia ⚘ Vermilion ⚘ Winsor Violet (Dioxazine)

MATERIALS

HB lead pencil ⚘ Nos. 000, 00, 0, 1 and 2 sable round brushes ⚘ Stretched watercolor paper ⚘ Transferring materials from page 15

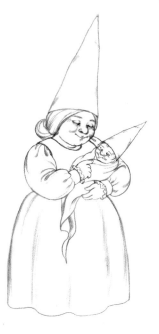

1 Sketch the drawing then transfer it to watercolor paper using transfer paper and a ballpoint pen that is out of ink.

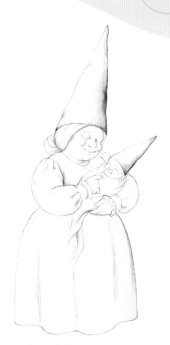

2 Create a base fleshtone by mixing a small amount of Olive Green with Indigo. Apply this with a no. 00 round along mother's hairline and the bottom of her hands, and on the facial contours of mother and child.

Use a no. 1 round to apply Winsor Violet (Dioxazine) to the blouse. Wet the skirt using a no. 2 round, then apply a light tint of Indigo to the mother's hair, skirt and the baby's blanket using a no. 1 round. Use a no. 0 round to apply a light tint of Caput Mortuum Violet to the sides of the cap, blending inward with clear water. When the shine is gone, apply a medium tint to the right side letting the tints blend together.

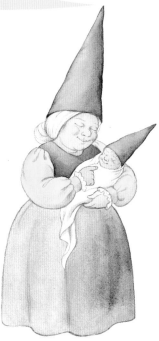

3 Mix a small amount of Burnt Sienna and Vermilion for a fleshtone. Wet the skin and apply this mixture with a no.1 round. Let dry.

Use a no. 00 round to apply Burnt Sienna to the bodice. Wet the skirt and, when the shine is gone, apply a medium tint of Winsor Violet (Dioxazine) to the skirt with a no. 1 round. Let dry. Wet the blouse sleeves then apply a light tint of Cadmium Yellow. While still wet, work in a darker tint of Cadmium Yellow to the areas that catch more light.

Wet the caps, let them dry briefly, then apply a medium shade of Vermilion to both sides of the caps, blending inward with clean water for highlights.

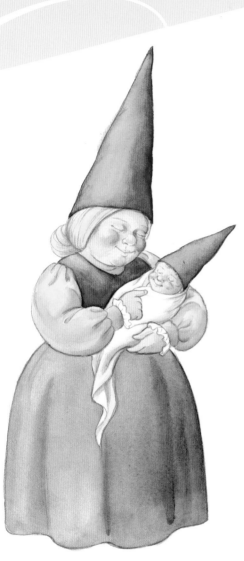

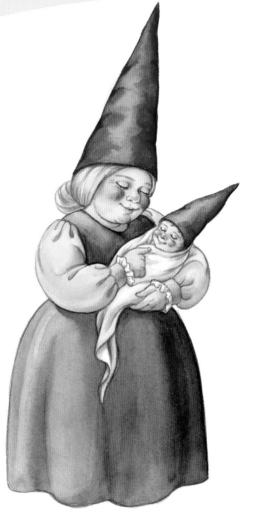

4 Wet the blouse, let this dry briefly then apply Cadmium Orange to the areas in shadow. Use a no. 0 round to apply a darker shade of Burnt Sienna to the bodice and let dry. Use a no. 000 round to apply a darker shade of the fleshtone to the areas of skin in shadow, especially the cheeks and under the mother's chin. Add a darker shade of Cadmium Yellow to the blouse areas facing the light. Wet the skirt, let this dry briefly then apply a darker shade of Winsor Violet (Dioxazine) to the folds with a no. 1 round. Mix a small amount of Cadmium Yellow and Chinese White and apply this to mother's hair with a no. 0 round. Using a no. 00 round, apply a medium tint of Indigo to the folds of the blanket. Let this dry briefly then apply a medium tint of Cobalt Turquoise to the folds in shadow.

5 Wet the cheeks and use a no. 000 round to apply Vermilion, blending carefully with clean water. Using a no. 000 round, apply Alizarin Crimson to the lips following the contours. Wet the caps and use a no. 1 round to apply Quinacridone Red to both sides of the caps, blending inward with clean water to show highlights. Let dry. Apply Indigo with a no. 00 round to the folds of the blanket farthest from the light source, and while still wet, add Cobalt Turquoise to the folds as they turn from the light. Use a no. 1 round to apply Payne's Gray to the part of the skirt in shadow. Add Indigo to the bodice over the Burnt Sienna using a no. 00 round. Use your pencil to emphasize the edges and folds of the cap, blouse and skirt. Use a dark tint of Sepia loaded on a no. 000 round to paint the lowered lids of the mother and baby. Wet the skirt and use a no. 1 round to apply a dark tint of Winsor Violet (Dioxazine) to the right side and along the folds.

PAINTING A DWARF

This female dwarf has all the dwarf attributes that have prepared her for battle. She has the wide head, large hands and barrel chest of her male counterparts, and an eager expression on her face.

~ YOU WILL NEED ~

PAINTS

Burnt Sienna ∾ Cadmium Orange ∾ Cadmium Yellow ∾ Caput Mortuum Violet ∾ Chinese Orange ∾ Cobalt Blue ∾ Cobalt Turquoise ∾ French Ultramarine Blue ∾ Hooker's Green ∾ Indigo ∾ Ivory Black ∾ Olive Green ∾ Quinacridone Red ∾ Raw Umber ∾ Sepia ∾ Vermilion ∾ Viridian ∾ Winsor Violet (Dioxazine) ∾ Yellow Ochre

MATERIALS

HB lead pencil ∾ Nos. 000, 00, 0 and 1 sable round brushes ∾ Stretched watercolor paper ∾ Transferring matierals from page 15

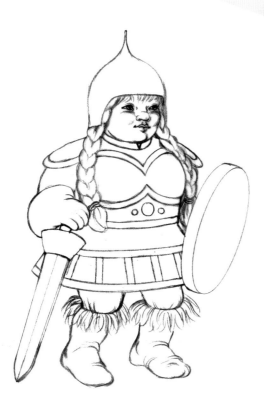

1 After building the figure with circles and ovals, add clothing, armor, boots and weapons by erasing old lines or drawing over the first drawing on a tracing paper overlay. Transfer the drawing to the watercolor paper using transfer paper and a ballpoint pen that is out of ink.

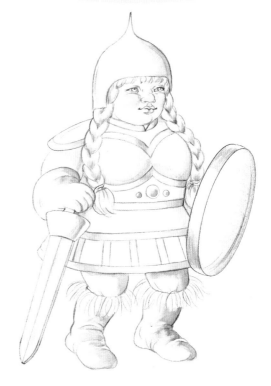

2 As you paint, keep in mind that the light source is from the upper left. Mix a small amount of Olive Green and Raw Umber, and apply this fleshtone base to the cheeks and face with a no. 0 round. Use a no. 1 round to apply a light tint of Winsor Violet (Dioxazine) on the bosom, neck, the skirt of the armor and behind the hand holding the sword. Use a no. 0 round to apply Indigo to the pants and helmet. Use a no. 0 round to add Sepia to the gloves and the boots. Use a no. 1 round to apply a light tint of Ivory Black to the sword and shield. Use a no. 00 round to add a light tint of Burnt Sienna to the V-shaped joints in the braids and the contours of the bands in her armor, blending inward with clean water. Wet the center jewel with a no. 000 round, and when the shine is gone apply Cobalt Blue. Do the same with the smaller jewels using Cadmium Orange.

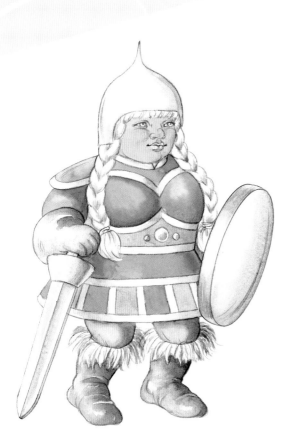

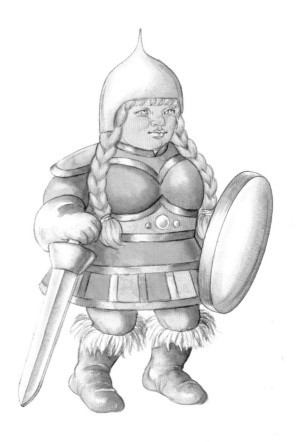

3 Mix a small amount of Burnt Sienna with a tiny amount of Vermilion for a fleshtone. Using a no. 1 round, apply it to the face. Wet the armor between the metal bands and apply a medium-light tint of Hooker's Green to the contours of the bosom. When the shine is gone apply a darker tint of Hooker's Green to the contours as they turn from the light. Wet the sword, helmet and shield and use a no. 1 round to apply Cobalt Turquoise to these areas as they turn from the light. Wet the pants and add a light tint of Winsor Violet (Dioxazine). When the shine is gone apply a darker tint to the right and under the lower edge of the armor. Wet the boots. When the shine is gone use a no. 1 round to apply Indigo. When the shine is gone, apply a darker tint of it to the right sides of the boots. Wet the glove and apply a medium tint of Indigo with a no. 0 round. Apply a medium-light tint of French Ultramarine Blue to the stomach area of the armor using a no. 0 round. Using a no. 000 round, apply a medium tint of Caput Mortuum Violet to the fringe on the boots.

4 Use a no. 0 round to apply a medium tint of Cadmium Yellow to the hair. When the shine is gone, add a darker tint to the V-shapes in the braids. Using a no. 0 round, apply Yellow Ochre to the metal bands, leaving highlights.

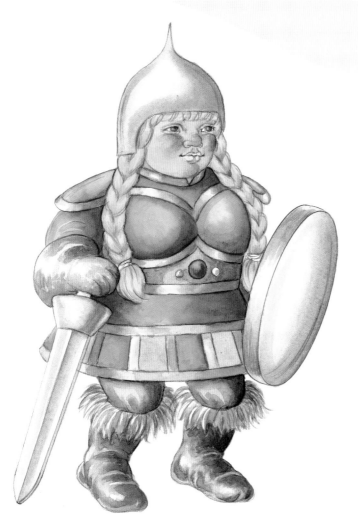

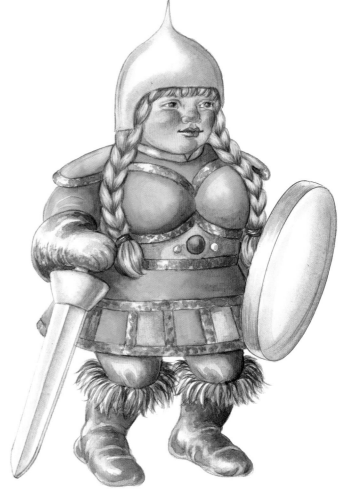

5 Use a no. 000 round to apply Burnt Sienna to the fringe on the boots. Use a no. 00 round to apply a darker tint of French Ultramarine Blue to the shaded parts of the stomach area. Use a no. 1 round to apply Viridian to the green areas in shadow. Apply a medium-dark tint of Indigo to the areas of the boots in shadow with a no. 0 round, and apply a medium tint of Indigo to the gloves with a no. 00 round. Wet her cheeks and apply Vermilion with a no. 000 round, blending outward with clean water. Wet the jewel and apply Quinacridone Red, leaving a lighter area where light falls. Using a no. 0 round, apply a darker tint of Cobalt Turquoise to the sword, helmet and shield.

6 Using a no. 00 round, dab a medium-dark tint of Burnt Sienna to the metal bands to create the look of hammered metal. Wet the lips using a no. 000 round and apply Vermilion, following the contours. Using a no. 000 round, apply a tiny amount of a darker tint of Vermilion to the arc of the cheeks and nose. Using a no. 000 round, apply strokes of Cadmium Orange to the braids and let dry. Using a no. 000 round, apply fine strokes of Chinese Orange to the Vs of the braids and on the bangs. Use a no. 000 round to paint the bands at the ends of the braids with Caput Mortuum Violet. Wet the pupils and with a no. 000 round and apply Sepia.

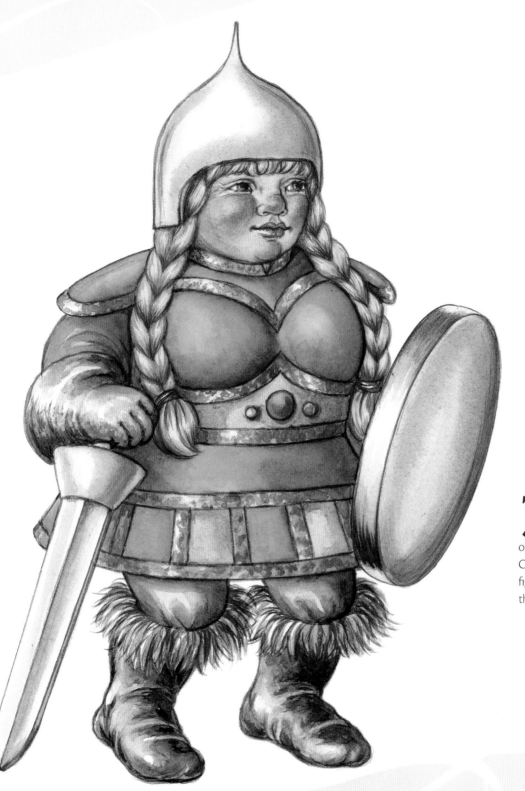

7 Using an HB lead pencil, draw the right side of the nose and nostrils, the edges of the shield, sword and helmet. Continue adding emphasis to the figure by drawing the edges of all the parts of the figure.

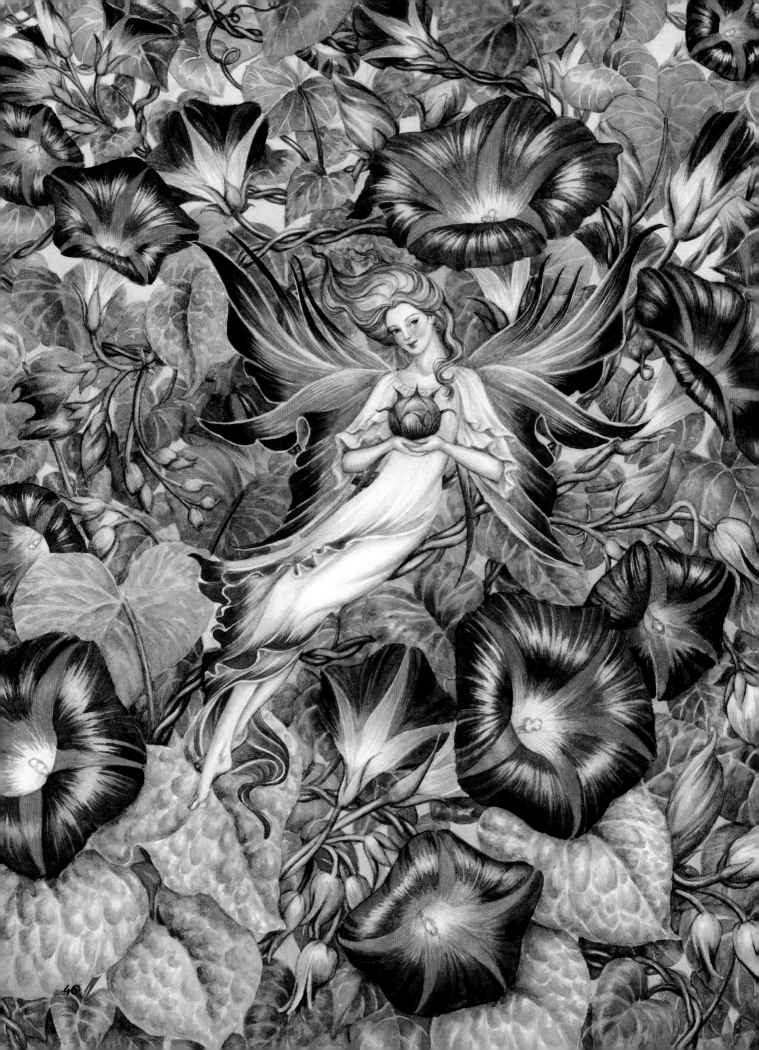

ELVEN CHARACTERS

IN THIS CHAPTER YOU'LL LEARN HOW TO CRE-
ATE A VARIETY OF ELVEN CREATURES. Each has
their own story to tell, from the innocence
of a baby sprite's first encounter with a butterfly
to the elf archer ready to defend his realm. Use
your favorite colors or attire to alter the mood
and adjust the surroundings if you'd like. It's
always a good idea to read through the steps first
and practice a step you are unfamiliar with before
beginning the entire painting. It may save you
time in the long run.

RAFE, WOOD ELF ARCHER

This figure was posed to draw your eyes to his. The lines of the cape, the side tunic opening, the bowstring and the strap across his chest all lead your eyes to his. His expression shows the confidence of one who learned how to use bow and arrows long ago.

~ YOU WILL NEED ~

PAINTS

Alizarin Crimson ⁓ Burnt Sienna ⁓ Burnt Umber ⁓ Cadmium Orange ⁓ Cadmium Red Deep ⁓ Caput Mortuum Violet ⁓ Cobalt Blue ⁓ Indigo ⁓ Ivory Black ⁓ Mars Black ⁓ New Gamboge ⁓ Olive Green ⁓ Raw Sienna ⁓ Sepia ⁓ Winsor Violet (Dioxazine) ⁓ Yellow Ochre

MATERIALS

HB lead pencil ⁓ Nos. 000, 00, 0, 1 and 4 sable round brushes ⁓ Stretched watercolor paper ⁓ Transferring materials from page 15

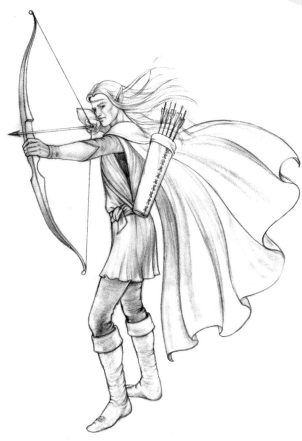

1 Sketch the drawing with an HB lead pencil and transfer it to stretched watercolor paper.

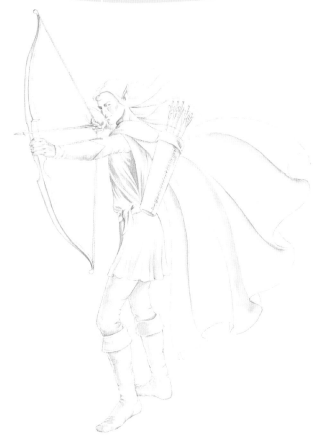

2 Mix a fleshtone with Burnt Sienna and Olive Green and apply this to the parts of the skin in shadow with a no. 1 round. Using a no. 1 round, apply Indigo to the shaded areas of the figure, cape and bow. Using a no. 0 round, apply Winsor Violet (Dioxazine) to shade the strands of his hair.

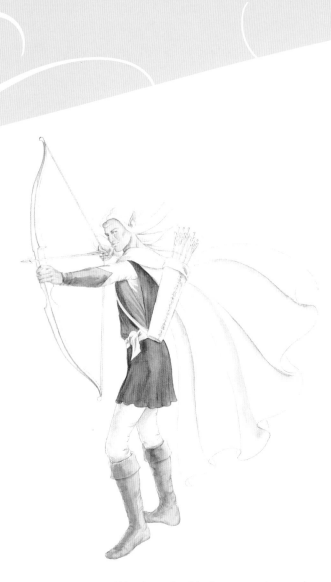

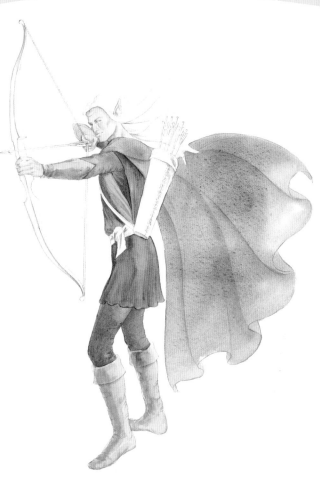

3 Wet the tunic with clean water then apply Alizarin Crimson with a no. 1 round. Clean the brush then apply a light tint of Yellow Ochre to his boots and arm shield. Let this dry briefly, then apply a darker tint of Yellow Ochre to the front of the boots.

4 Using a no. 4 round, wet the entire cape with clean water. Let this dry briefly, then apply a medium tint of Cobalt Blue. Wet the pants and apply Burnt Umber using a no. 1 round. Use a darker shade of the fleshtone mixture from Step 2 to paint the contours of flesh in shadow with a no. 00 round.

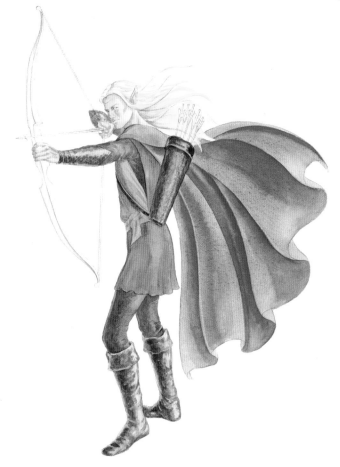

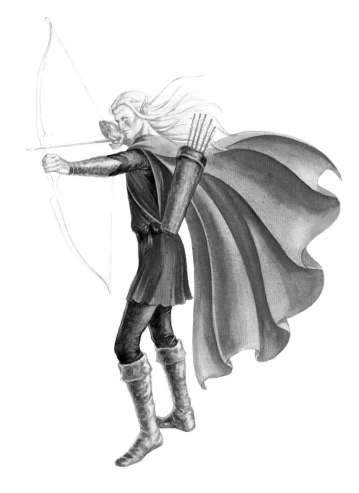

5 Using a no. 1 round, apply a light tint of New Gamboge to the hair. When dry, apply a light tint of Burnt Umber to areas in shadow. Using a no. 4 round, apply a darker tint of Cobalt Blue to the cape folds in shadow. Paint the darkest shadows of the cape with a mixture of Cobalt Blue and Indigo with a no. 1 round. Add details to the boots, arm shield and arrow quiver using a no. 00 round and a mixture of Burnt Sienna and Caput Mortuum Violet. With a no. 1 round, apply a light tint of this mixture to the belt.

6 With a no. 00 round, apply a mixture of Alizarin Crimson and Winsor Violet (Dioxazine) to the tunic folds in shadow. Use a darker tint of Sepia to add details to folds in the sleeve, inside the tunic, the belt, pants and arrow quiver. Using a no. 000 round, apply Raw Sienna to the arrow shafts. Mix the fleshtone mixture from Step 2 with Cadmium Red Deep. Use this to define the cheek and the areas of the hand in shadow with a no. 00 round.

7 Mix Sepia with Mars Black and apply a light tint to the bow using a no. 0 round. With a no. 000 round, apply Yellow Ochre to the arrows and bowstring. Apply a darker tint of Alizarin Crimson to the tunic folds to darken some shadows. Using a no. 000 round, apply Cadmium Orange and Cadmium Red Deep to the ends of the arrows. Using a no. 000 round, apply Ivory Black to the arrow tip. Rinse the brush and apply Cobalt Blue to the irises.

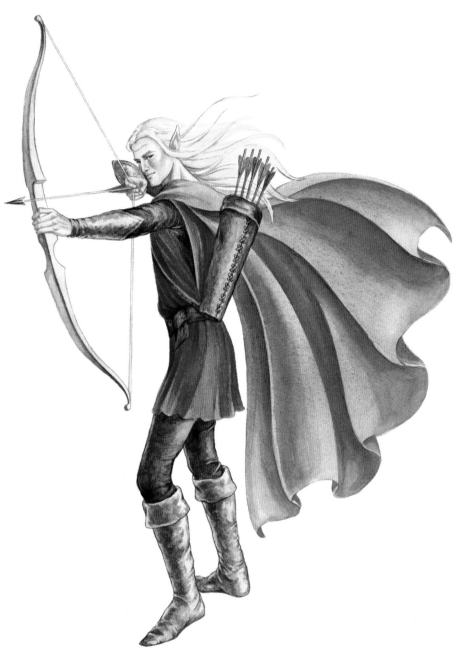

OLAR, FROST SPRITE

Olar is a friendly sprite whose frost brings the beginning of a long winter nap.

Over time, a salt technique will harm your paper, but the effect is captivating. You can guide the salt to certain portions of a picture but you can never quite predict the outcome, and that's the beauty of it.

Make sure you mix enough background color. The darkest backgrounds give the most striking results.

~YOU WILL NEED~

PAINTS

Antwerp Blue ❧ Cadmium Yellow Pale ❧ Chinese White ❧ Cobalt Turquoise ❧ Indigo ❧ New Gamboge ❧ Payne's Gray ❧ Permanent Sap Green ❧ Turquoise ❧ Turquoise Blue ❧ Ultramarine Blue (Green Shade) ❧ Viridian

MATERIALS

1½-inch (38mm) and ½-inch (12mm) acrylic flat brushes ❧ Craft knife ❧ HB lead pencil ❧ Facial tissue ❧ Masking fluid ❧ No. 1 acrylic round brush ❧ Nos. 000, 00, 0, 1 and 8 sable round brushes ❧ Soap ❧ Stretched watercolor paper ❧ Table salt ❧ Transferring materials from page 15

1 Sketch the drawing with an HB lead pencil, then transfer the drawing onto stretched watercolor paper. Add water to some masking fluid, and, using an acrylic brush dipped in soap, apply masking fluid to the entire figure. Use a no. 1 round for the small areas and a ½-inch (12mm) flat for larger areas.

2 Mix a large amount of a dark shade of Ultramarine Blue (Green Shade) with some Payne's Gray. Wet the entire painting surface using a 1½-inch (38mm) flat. Let this dry briefly then use the brush to apply the paint mixture, tilting the board to avoid streaks. Sprinkle table salt well above the painting surface and let this dry. Don't worry about foreground leaves at this point. Remove all the salt crystals with your fingertips.

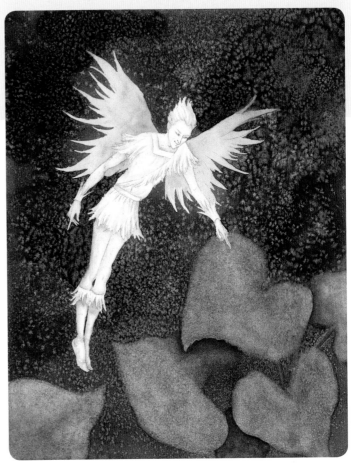

4 Using a no. 1 round, apply Permanent Sap Green where leaves are overlapped by other leaves. Add Antwerp Blue to create deeper shadows. Let this dry.

Remove the masking fluid from the sprite and, if necessary, retrace the figure with a pencil. Using a no. 0 round, apply Cobalt Turquoise to the areas of the skin in shadow and Turquoise Blue to the wings, boots and folds of his tunic and sash in shadow.

3 Rewet the entire surface with the 1½-inch (38mm) flat. Using a no. 8 round, apply uneven waves of the background mixture from Step 2 to the top three-fourths of the surface to vary the nighttime sky. Drop a bit more salt over these areas for an added layer of texture. Let this dry, then rub off the salt.

If the pencil lines of the leaves are obscured, retrace the shapes. Using a ½-inch (12mm) flat, wet the leaves and lift off some color with a facial tissue.

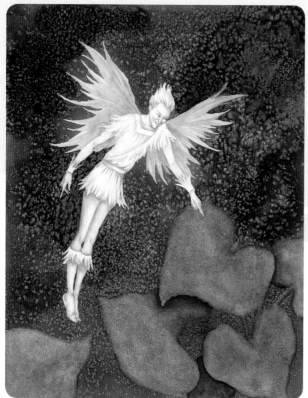

5 Using a no. 0 round, add Turquoise Blue between the folds of his tunic and to his hair and boots.
Paint the leaves following the mini demonstration on page 55.
Paint the wings following the mini demonstration on page 55.

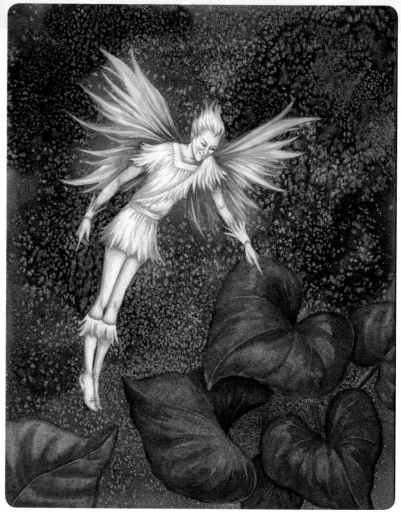

6 Using a no. 0 round, apply a light tint of Cobalt Turquoise to the entire figure. Use a no. 0 round to apply a dark tint of Cobalt Turquoise to the areas on the sprite's figure in shadow.

MINI DEMONSTRATION — *Painting Frost-Covered Leaves*

1 Using a no. 1 round, apply a medium tint of New Gamboge to the areas of the leaves in shadow.

2 Using a no. 1 round, paint the leaves and stems with Permanent Sap Green. Let this dry briefly, then apply Cadmium Yellow Pale to areas facing the light. Mix Permanent Sap Green with Antwerp Blue and apply it to the contours between the leaf veins in shadow using a no. 0 round.

3 Wet the leaves and apply salt from a distance. Let this dry. Use a craft blade to scratch the paper for a frost effect along the rim of the leaves and where they face the light. Using a no. 0 round, apply a dark tint of Indigo to the shadows. Use Chinese White loaded on a no. 000 round to paint the sparkles on the leaf. When dry, add Cobalt Turquoise to the sparkles.

MINI DEMONSTRATION — *Painting Olar's Wings*

1 With a no. 0 round, add Turquoise to the streaks in the wings.

2 Mix Cobalt Turquoise with Chinese White. Use a no. 000 round to add this to the wing's tips and to the ends of his hair. Use a no. 0 round to apply a dark tint of Cobalt Turquoise to the areas of the wings behind his shoulders.

3 Using a no. 0 round, apply a dark tint of Viridian to the base of the wings. Use a craft knife to scratch highlights on the wings where they face the light.

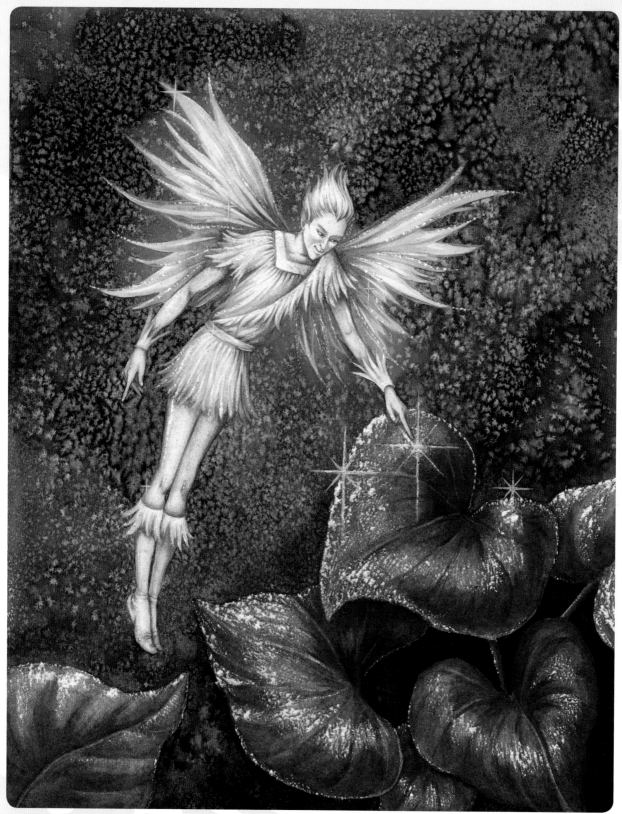

7 Use a no. 00 round to apply Cobalt Turquoise to his hair, face, legs, sash and hands where they face the light. Using a no. 0 round, apply Turquoise to the hair and legs in shadow. Using a craft knife, scratch some paint away from the figure to add sparkles to the sprite.

Using a no. 0 round, apply Ultramarine Blue (Green Shade) to the areas of the figure that turn from the light.

SUNDROP, RAINBOW SPRITE

Any artist who can paint a perfect rainbow without holding his or her breath deserves a big pat on the back. Happily, the rest of us can coax a little color into where it's needed and lift out some that has drifted too far. Have on hand soft tissues, dry brushes and a willingness to try and try again.

~ YOU WILL NEED ~

PAINTS

Burnt Sienna ~ Burnt Umber ~ Cadmium Orange ~ Cadmium Red ~ Cadmium Yellow ~ Chinese Orange ~ Cobalt Blue ~ Horizon Blue ~ Indigo ~ Permanent Sap Green ~ Quinacridone Red ~ Sepia ~ Viridian ~ Winsor Violet (Dioxazine)

MATERIALS

½-inch (12mm) and 1½-inch (38mm) sable flat brushes ~ HB lead pencil ~ Nos. 000, 00, 0, 2 and 3 sable round brushes ~ Stretched watercolor paper ~ Transferring materials from page 15

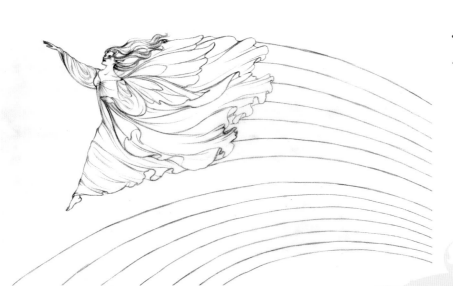

1 Sketch the sprite and rainbow with an HB lead pencil and transfer the drawing to stretched watercolor paper.

PRACTICE PAINTING THE RAINBOW

I strongly suggest that you first practice painting the rainbow on scrap paper to get the feel for the wet-into-wet blending of the colors.

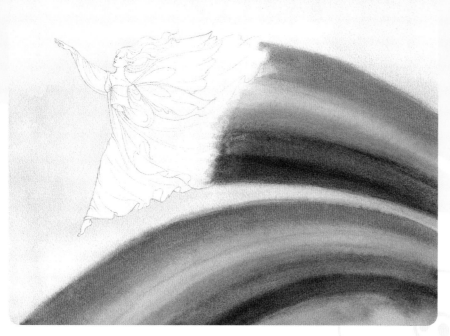

2 In separate pans on your palette, mix with a bit of water to a creamy consistencey of rainbow colors: Quinacridone Red, Cadmium Orange, Cadmium Yellow, Permanent Sap Green, Cobalt Blue and Winsor Violet (Dioxazine). Wet the entire surface using a 1½-inch (38mm) flat. Apply a light tint of Indigo to the entire surface except for the sprite using the same brush. Let this dry briefly.

Follow the mini demonstration below to create the rainbow.

KEEPING THE RAINBOW'S COLORS CLEAN
If any of the rainbow's colors trail unevenly into the color above it, use a dry no. 1 round to carefully lift the color out.

MINI DEMONSTRATION ～ *Painting the Rainbow*

1 Using a ½-inch (12mm) flat, wet the area the rainbow will occupy and let this dry briefly. Load the flat with Quinacridone Red and paint the arc at the top.

2 Clean the ½-inch (12mm) flat, and, working wet-into-wet, overlap the bottom edge of the red with Cadmium Orange.

3 Follow the same process to add the Cadmium Yellow, Permanent Sap Green, Cobalt Blue and Winsor Violet (Dioxazine). Let this dry then adjust any areas where the color is uneven with a no. 000 round.

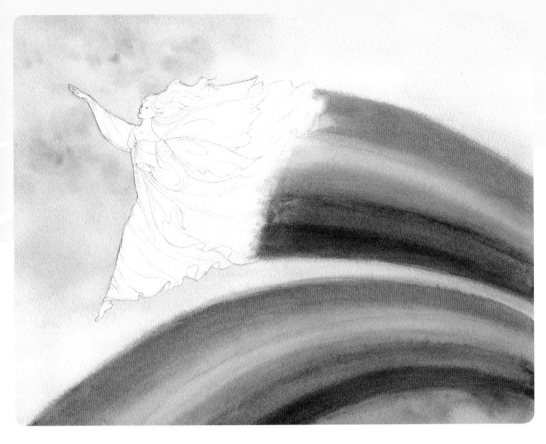

3 Using a 1½-inch (38mm) flat, apply Horizon Blue to the upper left corner of the painting.

4 Using a no. 2 round, paint Cobalt Blue clouds one at a time in free-form shapes behind the sprite and rainbows. When the shine is gone, add Quinacridone Red to cloud contours. Paint the clouds into the rainbows for a transparent effect.

5 Mix a dark fleshtone of Burnt Sienna, Burnt Umber and Cadmium Red. Using a no. 00 round, paint the sprite's face, neck, hands and foot. Apply Chinese Orange to the hair using a no. 0 round. Use the no. 0 round to paint the rainbow colors up to the sprite's wings and across the lower part of her garment, following the techniques in the mini demonstration on page 58. Use clean water and a no. 0 round to dilute the edges of the colors as they reach white paper (such as her wings and dress) and let this dry.

6 Using a no. 3 round, wet the sprite's wings. Use the no. 3 round to paint a rainbow following the technique in the mini demonstration on page 58, starting at the outer edge of the wing and ending behind her neck and shoulders.

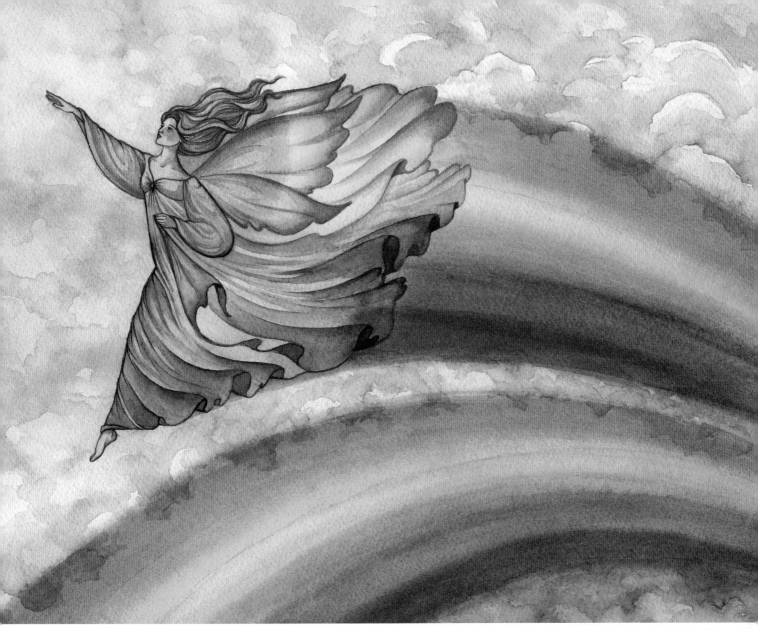

7 Using a no. 00 round, apply darker tints of the rainbow colors to the top of the folds of her cape and gown. Use the no. 00 round to apply Cadmium Orange to the underside of her cape, Viridian under the green folds of her gown and a mixture of Cobalt Blue and Winsor Violet (Dioxazine) under the violet folds in her gown. Using a no. 0 round, apply Burnt Umber to the areas of skin in shadow. Using a no. 000 round, apply Sepia to the outer edge of her skin. Using a no. 0 round, apply Winsor Violet (Dioxazine) under the hem of the gown, continuing to the bottom edge of the rainbow.

Wet Sundrop's cheek and apply Cadmium Red with a no. 000 round. Use a no. 00 round to apply a darker tint of fleshtone to the areas of the face, neck and hands in shadow. Use a no. 000 round to apply Quinacridone Red to her lips. Mix Cadmium Orange and Burnt Sienna and use a no. 00 round to apply shadows to her hair. With a no. 000 round, paint the outer edges of her hair, the eyebrow, nose and fingers a dark shade of Sepia. Use a clean no. 00 round to paint the outer edge of her wings Quinacridone Red.

JEENA AND HER NEW FRIEND

Sometimes you'll want a deep background for a sharp contrast against delicate foreground colors and subject matter.

By applying a liquid mask, you will ensure uniformity in the many spaces between the pear blossoms.

Make sure you mix lots of color so you won't lose time when laying down the background wash.

~ YOU WILL NEED ~

PAINTS

Alizarin Crimson ✎ Antwerp Blue ✎ Burnt Sienna ✎ Burnt Umber ✎ Cadmium Orange ✎ Cadmium Yellow Deep ✎ Caput Mortuum Violet ✎ Chinese Orange ✎ Chinese White ✎ Cobalt Blue ✎ Cobalt Turquoise ✎ Indanthrene Blue ✎ Indigo ✎ New Gamboge ✎ Olive Green ✎ Oxide of Chromium ✎ Payne's Gray ✎ Permanent Rose ✎ Permanent Sap Green ✎ Quinacridone Red ✎ Raw Umber ✎ Vermilion ✎ Viridian ✎ Yellow Ochre

MATERIALS

1½-inch (38mm) sable flat brush ✎ Facial tissue ✎ HB lead pencil ✎ Masking fluid ✎ No. 1 acrylic round brush ✎ Nos. 000, 00, 0, 1 and 2 sable round brushes ✎ Soap ✎ Stretched watercolor paper ✎ Transferring materials from page 15

1 Sketch the drawing with a pencil then transfer it to stretched watercolor paper. Using a no.1 bristle round, first swished across a wet bar of soap, apply masking fluid to all the foreground elements.

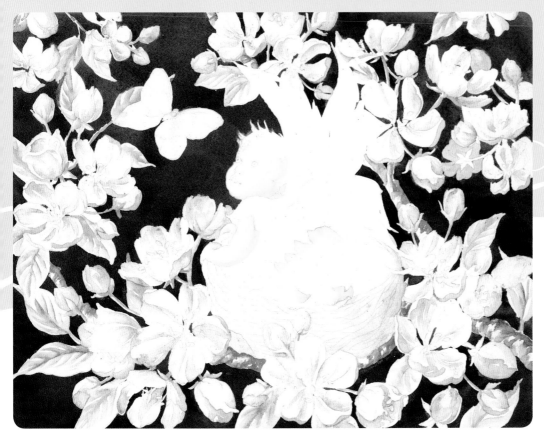

2 In separate pans, add water to make creamy consistencies of Oxide of Chromium, Raw Umber, Payne's Gray and a small amount of Alizarin Crimson. Wet the surface of your painting thoroughly using a 1½-inch (38mm) flat. Let this dry briefly. Use the flat to apply the colors next to each other. Help them blend together by tilting the board back and forth. Use facial tissue to remove any paint on the masking fluid. Let this dry completely. Remove the mask carefully using your fingertips or a ball of dry mask.

Using a no. 1 round, apply Indigo to the back of the nest. Mix together Burnt Sienna and Olive Green. Apply this to the shaded areas of the face, arm and legs with a no. 00 round. For the sides of the branches in shadow, mix Indigo with Caput Mortuum Violet and apply it to these areas using a no. 00 round.

Paint the flowers following the mini demonstration on this page.

MINI DEMONSTRATION — *Starting the Flowers and Leaves*

1 Mix together Cobalt Blue, Permanent Rose and Payne's Gray and apply this to the parts of the petals in shadow using a no.1 round.

2 Using an no. 1 round, apply a mixture of Permanent Rose and Quinacridone Red to the flowers, leaving white paper for highlights.

3 Wetting each leaf at a time with a no. 1 round, apply light tints of Permanent Sap Green to the leaf's contours in shadow and use a darker shade for the deepest shadows. Use a no. 1 round loaded with clean water to lift out highlights. Let this dry briefly, then apply a darker tint of Permanent Sap Green to the areas between the veins that turn most from the light.

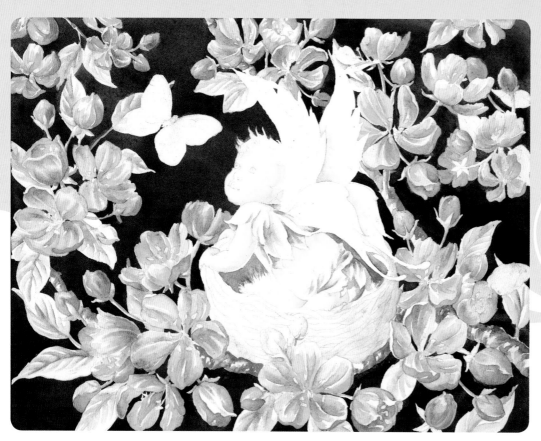

3 Wet the space between the wings with clear water using a no. 1 round. Then apply Cobalt Turquoise where the wings meet, blending outward with clear water. Mix together Viridian and Indanthrene Blue and apply this under the leaves of the sprite's clothing with a no. 1 round. Use the round to apply a medium tint of Indigo inside of the nest.

4 Create a fleshtone by mixing Vermilion with Burnt Sienna. Apply this to all skin areas using a no. 0 round. Clean the round then apply a medium tint to the sides and back of the nest. Add Yellow Ochre to the front of the nest where the light hits. With a no. 00 round, apply Raw Umber to the branches inside the nest. Wet the sprite's cheeks, then use a no. 000 round to apply Quinocridone Red, carefully blending outward with clean water. Use a no. 0 round to paint the outfit with Olive Green.

Paint the butterfly following the mini demonstration on page 67.

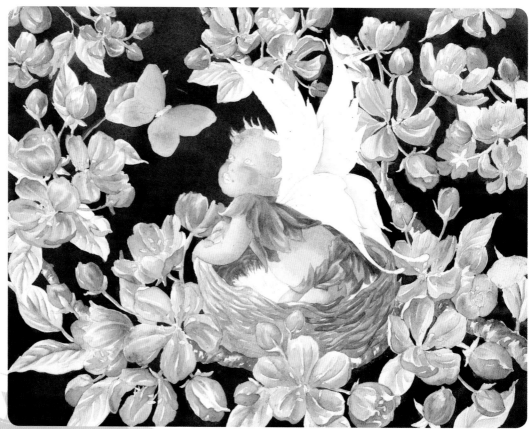

SPEED UP THE DRYING TIME
You can use a hair dryer to help the paint dry faster. Be sure to hold it at least 8 inches (20cm) away from the surface so the heat from the hair dryer does not make the mask harder to remove.

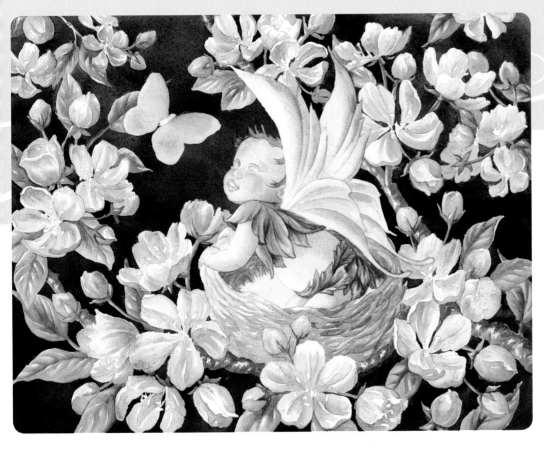

5 Using a no. 2 round, apply Permanent Sap Green to the outer edges of the leaves on the outfit. Use the round to apply Burnt Sienna to the hair. Using a no. 000 round, wet the sprite's irises and apply Cobalt Turquoise. Wet the cheeks with the no. 000 round and apply a tiny amount of Quinacridone Red to the lips and cheeks, blending outward on the cheeks with clean water. Mix a light tint of Yellow Ochre with Chinese White and apply this to the fluffy bottom of the nest with a no. 00 round. Using a no. 1 round, apply Burnt Umber to the branches.

Complete the flowers following the mini demonstration on this page.

Paint the wings following the mini demonstration on page 66.

MINI DEMONSTRATION — *Completeing the Flowers*

1 Mix together Cobalt Blue, Permanent Rose and a bit of Payne's Grey. Apply this to the flower petals in shadow using a no. 1 round. Using a no. 1 round, apply Indanthrene Blue to the leaves and calyxes in shadow.

2 Mix together Chinese White and Cadmium Yellow Deep. Using a no. 000 round, paint the flower stamens. Add a medium dark tint of Indigo to the areas of the petals and buds in shadow.

3 Using a no. 000 round, apply a mixture of Cadmium Yellow Deep and Chinese Orange to the outer edges of the stamens. Using a no. 1 round, apply a medium tint of Quinacridone Red to the flower contours in shadow. Where needed, touch up the spaces between flowers with the background color.

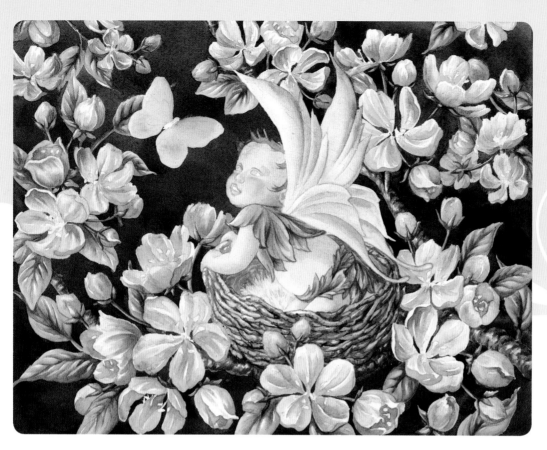

6 Using a no. 1 round, apply Caput Mortuum Violet to the sides of the branches in shadow. Using the same brush, apply Burnt Umber to the parts of the branch hit with light, Sepia to the side of the nest, and Antwerp Blue to the part of the nest in shadow.

MINI DEMONSTRATION ~ *Painting Translucent Wings*

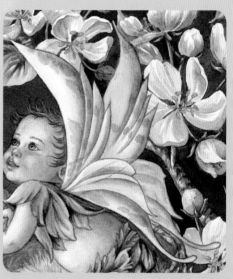

1 Wet the foreground wing and apply a light tint of Cobalt Blue using a no. 1 round. Let this dry briefly, then apply a darker shade to the contours. Let this dry and do the same to the other wing.

2 Add a darker tint of Cobalt Blue to the wing contours.

3 Using a finely sharpened HB lead pencil, draw the branches and flowers behind the sprite's wings. Use light tints of the branch and flower colors to paint them, giving the wings a look of transparency.

MINI DEMONSTRATION ~ *Painting the Butterfly*

1 Wet the butterfly using a no. 00 round then cover the butterfly with New Gamboge. Let this dry briefly then create details with Cadmium Yellow Deep and Cadmium Orange.

2 Clean the brush then use it to apply a dark tint of Raw Umber to the veins of the butterfly wings. Apply Cadmium Orange to the upper wings with a no. 00 round. Using a no. 00 round, apply a Burnt Umber pattern to the outer edges of the wings, body and antennae.

3 Using a no. 000 round, apply Burnt Umber to the veins of the butterfly wings, and using the same brush, apply a mixture of Chinese White and Yellow Ochre to the antennae and the body.

7 Using a no. 00 round loaded with clean water, lift color from the lower left corner in the shape of two leaves. Do the same to add a leaf at the lower right corner and above to balance the composition. Apply light and dark tints of Permanent Sap Green to these leaves in the same manner as you did the others. Using a no. 00 round, apply Olive Green to the left side of the face and under the lower lip. Apply a darker tint of the fleshtone mixture from Step 4 to the right side of the sprite's head. Apply Yellow Ochre to Jeena's hair, and, when it's dry, apply strokes of Burnt Umber.

Wet the sprite's entire midsection, arms and legs. Let this dry briefly then apply Olive Green to the back of the arms, the back of the midsection and to the back of the legs. Using a no. 000 round, apply Indanthrene Blue to the irises. Let dry and add a Chinese White highlight using the no 000 round. Use the round to add a medium-dark tint of Indigo to the areas of the outfit in shadow.

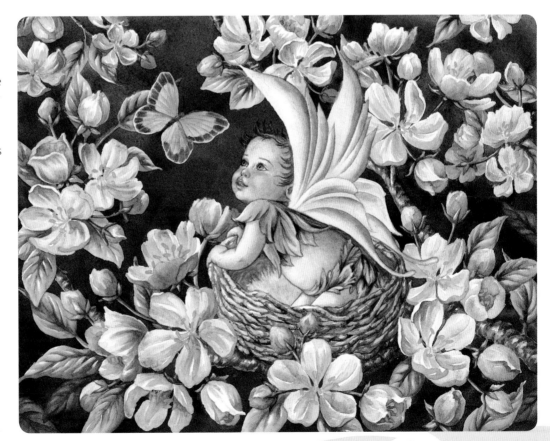

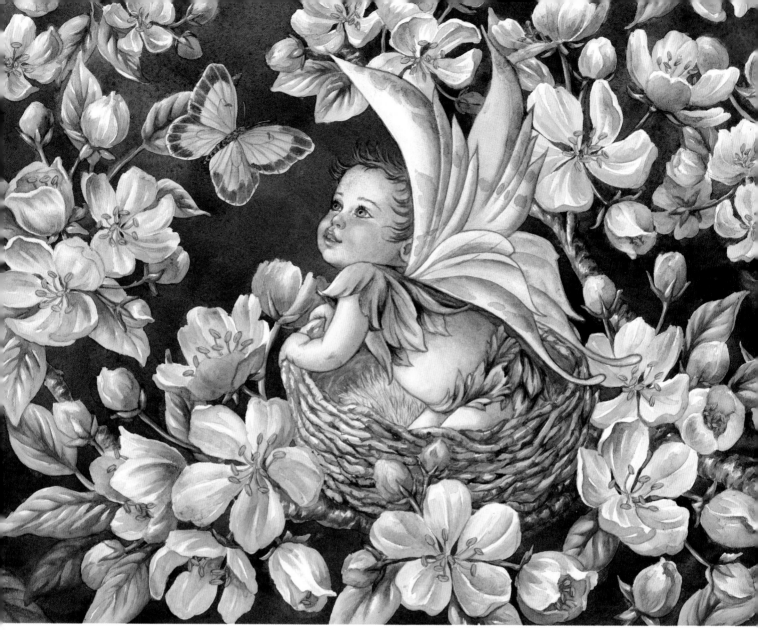

8 Paint the butterfly following the mini demonstration on page 67.

DEMONSTRATION
AMBER, FALL SPRITE

Fall leaves offer the perfect opportunity to let loose with color, tilting your paper back and forth, allowing the colors to harmonize. Adding spots of color lends interest and character to the leaves. It's not necessary to use liquid mask for the leaf veins. You can coax the veins out by painting them with clear water and lifting out the color with a tissue. Using the mask, however, gives you a lighter leaf vein. Try both to see which you prefer.

⟨ YOU WILL NEED ⟩

PAINTS

Alizarin Carmine ⁓ Alizarin Crimson ⁓ Burnt Sienna ⁓ Burnt Umber ⁓ Cadmium Orange ⁓ Cadmium Yellow ⁓ Cadmium Yellow Deep ⁓ Cadmium Yellow Pale ⁓ Caput Mortuum Violet ⁓ Chinese Orange ⁓ Chinese White ⁓ Indigo ⁓ Ivory Black ⁓ Olive Green ⁓ Oxide of Chromium ⁓ Permanent Magenta ⁓ Permanent Mauve ⁓ Permanent Rose ⁓ Permanent Sap Green ⁓ Raw Umber ⁓ Sepia ⁓ Ultramarine Blue (Green Shade) ⁓ Vermilion ⁓ Viridian ⁓ Winsor Orange ⁓ Winsor Violet (Dioxazine)

MATERIALS

HB lead pencil ⁓ Masking fluid ⁓ No. 1 acrylic round ⁓ Nos. 000, 00, 0 and 1 sable round brushes ⁓ Stretched watercolor paper ⁓ Transferring materials from page 15

1 Sketch the drawing with a pencil then transfer it to stretched watercolor paper.

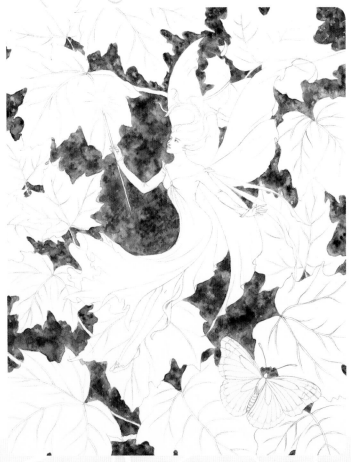

2 Wet one section of the background at a time with a no. 1 round and apply a light tint of Sepia with a no. 00 round. Let this dry briefly, then use the tip of the brush to apply dabs of Permanent Mauve, Caput Mortuum Violet, Burnt Sienna and a darker tint of Sepia within each section. Let this dry. Add water to a small amount of masking fluid, and apply it to the leaf veins, wand and butterfly with a no. 1 acrylic round.

69

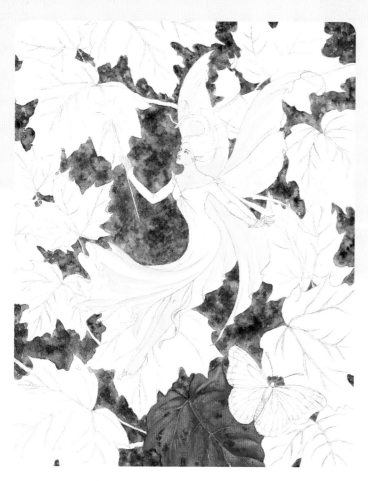

3 Mix together Vermilion and Burnt Sienna for a fleshtone and apply it to the skin with a no. 0 round. Using a no. 1 round, apply Cadmium Yellow Pale to the wings and the dress bottom, following the flow of the dress.

Paint the leaf following the mini demonstration on this page.

MINI DEMONSTRATION — *Painting the Leaf by Layering Colors*

1 Wet the leaf with a no. 1 round and apply a tint of Caput Mortuum Violet. Let this dry briefly.

2 Apply Permanent Rose over the leaf, adding plain water to the leaf's left side. Let this dry briefly

3 Apply Chinese Orange to the leaf's lighter side and add a darker tint of Permanent Rose, creating contours and shadow between the veins. Let this dry briefly, then use the tip of the no. 1 round to apply spots of Permanent Magenta and let dry.

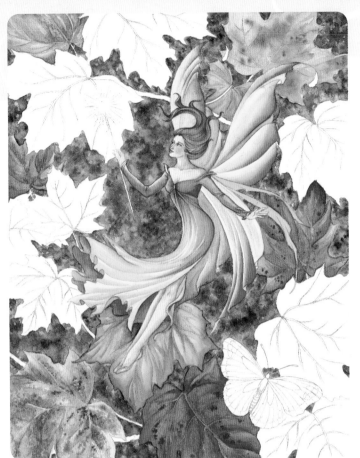

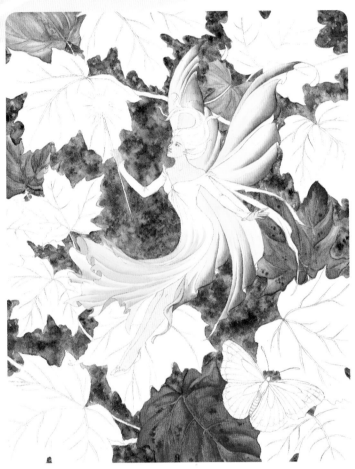

5 Using a no. 00 round, apply Vermilion to the bodice and underside of her dress. Blend color away from the bodice with clean water, leaving highlights. Using a no. 0 round, apply Cadmium Orange to her hair, sleeves, bodice and to the curve of her hip, blending away from the darkest color with clean water. Let this dry. Apply a medium tint of Vermilion to her hair, sleeves, bodice and hip area. Let this dry. Using a no. 000 round, apply Alizarin Carmine to the strands of her hair and the folds of her dress. Add Winsor Orange to the underside of her dress. Apply Cadmium Orange to thin the strands of her wing. Still using the no. 000 round, apply Alizarin Crimson to her lips, Burnt Umber to her eyes and Cadmium Yellow Pale and Cadmium Orange to her slippers.

Create a greenish yellow leaf following the mini demonstration on page 72 and using Oxide of Chromium, Cadmium Yellow and Permanent Sap Green

Create a purplish orange leaf by following the mini demonstration on page 70 and using Caput Mortuum Violet, Burnt Umber, Cadmium Orange and Winsor Violet (Dioxazine).

Create an orangish yellow leaf by following the mini demonstration on page 70 and using Raw Umber, Olive Green and Vermilion, Alizarin Crimson and Cadmium Yellow Pale.

4 Use a no. 00 round to apply Vermilion between the sprite's wing folds and blend with the no. 00 round dipped in clean water. Apply Cadmium Yellow Pale to the dress folds, starting at the hem and blending upward with clean water on the no. 00 round. Let this dry. Apply Cadmium Orange inside the dress folds.

Create reddish purple leaves by following the process outlined in the mini demonstration on page 70 using the following colors: Caput Mortuum Violet for the base; Winsor Violet (Dioxazine) for the light areas; Permanent Rose for the shadows on one leaf; Burnt Umber for the light areas; Permanent Rose for the shadows, and Burnt Umber for the spots.

Create greenish gold leaves by following the process outlined in the mini demonstration on page 72. Use Raw Umber for the base of the leaves. Use Olive Green, Oxide of Chromium and Viridian for one of the leaves and Viridian and Raw Umber for the other.

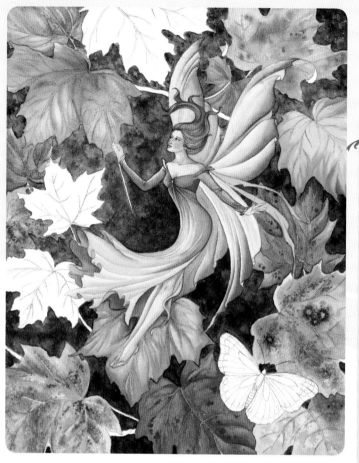

1 Wet the leaf behind the wand with a no. 1 round and apply Cadmium Yellow Pale to the outer edge. Tilt the paper in the opposite direction so the color blends into the clear water.

2 Working wet-into-wet, add a band of Cadmium Yellow along the outer edge of the leaf. Let this dry briefly, then apply Cadmium Yellow Deep inside the outer edge of the leaf and let dry.

3 Add a mixture of Permanent Sap Green and Cadmium Yellow between the veins along the leaf's top and let dry briefly.

4 Add a darker tint of Permanent Sap Green and Cadmium Yellow Pale and follow the contours of the shapes between the veins. Before it dries, add a medium tint of Vermilion to the outer edge.

6 Using a no. 0 round, add a dark shade of Sepia to the bottom half of the background, starting from the bottom and working upward. Let this dry briefly, then dab spots of Winsor Violet (Dioxazine) into the Sepia. Halfway up the painting, dilute the Sepia and continue painting the background up to the top, adding spots with a lighter tint of Winsor Violet (Dioxazine). Let this dry.

Create the leaf the wand is touching by following the mini demonstration on this page.

Paint the leaf above the butterfly following the mini demonstration on page 70 and using Cadmium Yellow Pale, Chinese Orange, Raw Umber and Permanent Sap Green. Create the spots with Caput Mortuum Violet, Raw Umber and Burnt Umber.

Create a greenish gray leaf following the mini demonstration on page 70 and using mixture of Permanent Sap Green and Cadmium Yellow Pale as well as Caput Mortuum Violet for the center and Oxide of Chromium for the spots.

Create a yellow-green leaf following the mini demonstration on this page and using Cadmium Yellow and mixture of Permanent Sap Green and Cadmium Yellow Pale.

Create a yellowish violet leaf following the demonstration on page 70 and using Winsor Violet (Dioxazine), Sepia, Cadmium Yellow Pale and Cadmium Orange.

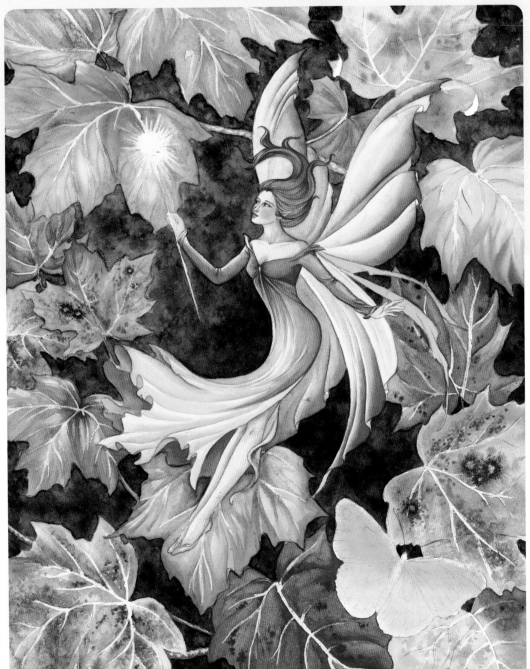

7 Create an orangish red leaf following the mini demonstration on page 70 and using Caput Mortuum Violet, Permanent Rose, Cadmium Yellow Pale and Cadmium Yellow Deep for the contours between the veins.

Create a magenta leaf following the mini demonstration on page 72 and using Caput Mortuum Violet, Permanent Rose and Winsor Violet (Dioxazine) for the contours between the veins.

Paint the remaining leaf following the mini demonstration on page 70 and using Raw Umber, Vermilion and Cadmium Yellow Pale.

Using a no. 1 round, apply a dark tint of Indigo to the background, increasing its contrast to the foreground. Let this dry.

Remove the masking fluid from the butterfly. Working wet-into-wet, apply Cadmium Yellow Pale to the bottom of the wings with a no. 0 round. Tilt the paper back and apply Cadmium Orange to the top. Let this dry completely.

Remove the liquid mask from the leaf veins with your fingertips. Run your fingers over the entire surface to make sure it's all gone.

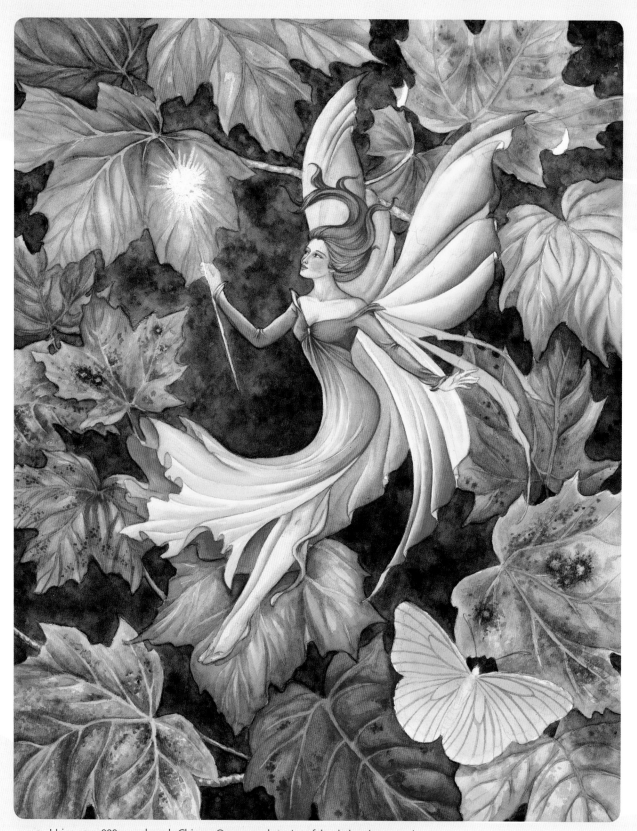

8 Using a no. 000 round, apply Chinese Orange to the veins of the darkest leaves and Cadmium Yellow Pale to the rest. Create a shadow under the butterfly's right wing with Ultramarine Blue (Green Shade). Mix Winsor Violet (Dioxazine) and Chinese Orange and apply it to the contours between the veins of all the leaves where they turn from the light.

Using a no. 000 round, apply a mixture of Cadmium Orange and Burnt Sienna to the veins of the butterfly. With a no. 1 round, apply a medium dark shade of Permanent Sap Green along the edges of the predominantly green leaves and between the veins of the leaf behind the wand.

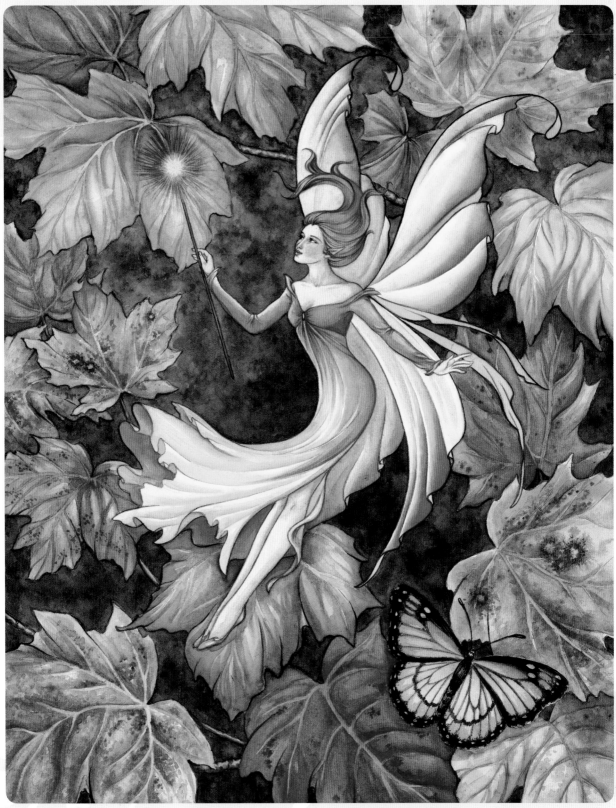

9 Using a no. 000 round, apply Ivory Black to the outer edge of the sprite's wings and the foreground hem of her dress. Use the same brush to add Sepia to her hair and along the edge of her skin. Add Ivory Black to the details of the monarch butterfly with a no. 00 round. Using a no. 000 round, add Cadmium Orange rays radiating from the center of her wand out. Use the same brush to apply Caput Mortuum Violet to the edges of her dress and to the outer edges of the leaves in shadow. Using a no. 000 round, paint the markings of the butterfly with Chinese White.

DEMONSTRATION
VERILIO, GREEN MAN

Green Man was a revered figure long before redwoods reached great heights. He represents the will of all things that sprout from the ground to flourish and reach for the sky. He is wise and as gentle as he is strong, fiercely protecting his domain.

Imagine all the shades of green you can create by glazing cool and warm greens over cool and warm blues and turquoises. Painting Verilio will immerse you in many tints of one of the most soothing colors of your palette.

～ YOU WILL NEED ～

PAINTS

Antwerp Blue ～ Burnt Sienna ～ Burnt Umber ～ Cadmium Yellow ～ Cadmium Yellow Pale ～ Chinese Orange ～ Cobalt Blue ～ Cobalt Turquoise ～ Hooker's Green ～ Indian Red ～ Indigo ～ Ivory Black ～ Olive Green ～ Oxide of Chromium ～ Payne's Gray ～ Permanent Sap Green ～ Sepia ～ Viridian ～ Winsor Emerald ～ Yellow Ochre

MATERIALS

1½-inch (38mm) sable flat brush ～ Nos. 000, 00, 0, 1, 2 and 4 sable round brushes ～ HB lead pencil ～ Stretched watercolor paper ～ Transferring materials from page 15

1 Sketch the drawing with an HB lead pencil then transfer it to the stretched watercolor paper. Add some shading using the pencil.

2 Wet the entire area with a 1½-inch (38mm) flat. Apply a light tint of Cadmium Yellow Pale to the entire surface. Working wet-into-wet, apply a mixture of Cadmium Yellow to foreground shapes and Permanent Sap Green to background ones with the 1½-inch (38mm) flat.

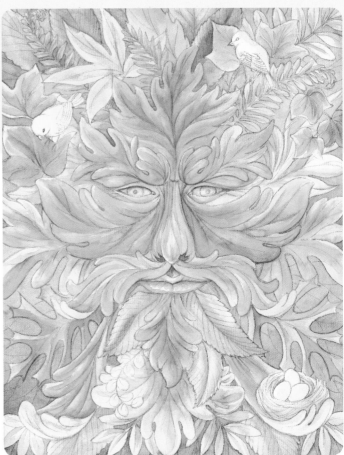

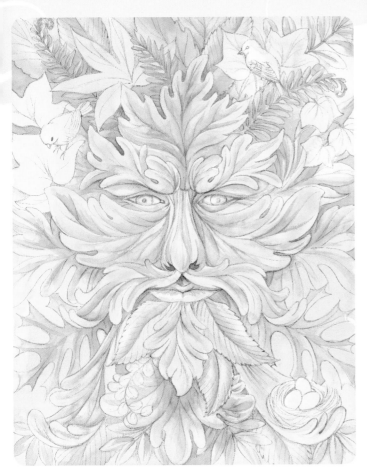

3 Mix together a light tint of Cadmium Yellow Pale and Olive Green. Using a no. 2 round, apply this to the contours of the foreground leaves and to the ferns behind Verilio's head. Let this dry briefly, then apply a darker tint of the same mixture to the leaf contours in shadow. Using a no. 1 round, apply a medium tint of Permanent Sap Green behind the foreground and midground leaves.

4 Using a no. 1 round, apply a medium tint of Antwerp Blue to the background and to the shadow side of the nest. Mix Cadmium Yellow with Permanent Sap Green and apply it to the foreground leaves with a no. 1 round. Apply a mixture of Yellow Ochre and Burnt Umber to some leaves for variety. Using a no. 1 round, apply a light tint of Hooker's Green to the upper eyelids. Wet the ivy leaves behind the birds with clear water, and, working wet-into-wet, apply a mixture of Cadmium Yellow Pale and Olive Green, blending to the edges. Let this dry briefly, then use a no. 000 round to apply Oxide of Chromium to the leaf veins. Pencil in background leaves on each side of his chin.

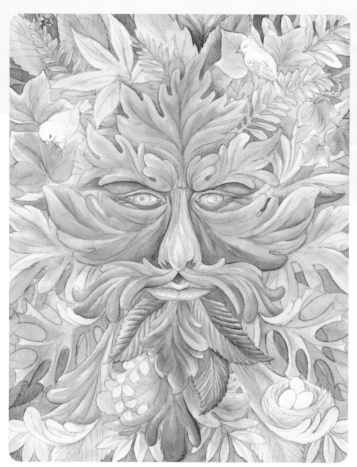

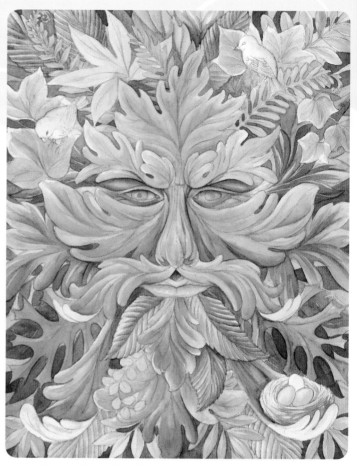

5 Using a no. 0 round, apply Hooker's Green to the top and bottom eyelids, behind the eyebrows, to the forehead leaf and to the contours of the mustache in shadow. On the most distant leaves, apply a medium tint of Oxide of Chromium using a no. 0 round.

6 Apply a darker tint of Oxide of Chromium to other background leaves with a no. 0 round. Use a mixture of Oxide of Chromium and a bit of Ivory Black to paint warm-colored veins on the chestnut leaves with a no. 000 round. Using a no. 1 round, apply Permanent Sap Green to the oak leaves on each side of his chin. Use a no. 0 round to apply Permanent Sap Green to midground leaves on each side of the eyebrows. Use a mixture of Permanent Sap Green and Ivory Black behind the foreground leaves. Apply Permanent Sap Green behind the fern on which the bird at the upper right perches. Using a no. 00 round, apply Cadmium Yellow Pale to the tendril of small round leaves at his chin. Using a no. 4 round, apply Cadmium Yellow Pale to the foreground leaves. When the shine is gone, apply Permanent Sap Green to the shadow side of the leaves.

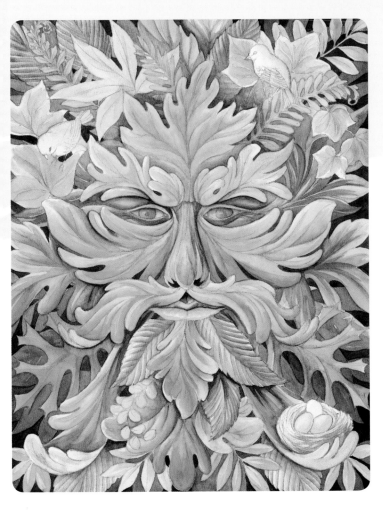

7 Mix Viridian and Ivory Black. With a no. 1 round, apply this to the background and the shadow areas of the upper and lower lids, nostrils, upper lip, cheeks, forehead leaf and chin leaves. Use a lighter tint of this mixture to paint behind all the leaves. Using a no. 1 round, apply Cobalt Blue under the upturned ends of the mustache and beard leaves.

Paint the bluebirds following the mini demonstration on this page.

MINI DEMONSTRATION — *Painting the Bluebirds*

1 Apply Cobalt Turquoise to the birds with a no. 00 round.

2 Wet the birds with clear water, then use a no. 1 round to apply Cobalt Blue. Let this dry briefly, then apply a darker tint to add contour and shadows to the birds. Using a no. 000 round, add details to the wings and feathers with Cobalt Blue. Add Cobalt Turquoise where the light hits the birds. Apply Payne's Gray to the beaks and legs. Using a no. 00 round, apply Chinese Orange to the left bird's chest.

3 With a no. 00 round, apply Antwerp Blue to refine the birds' shadows.

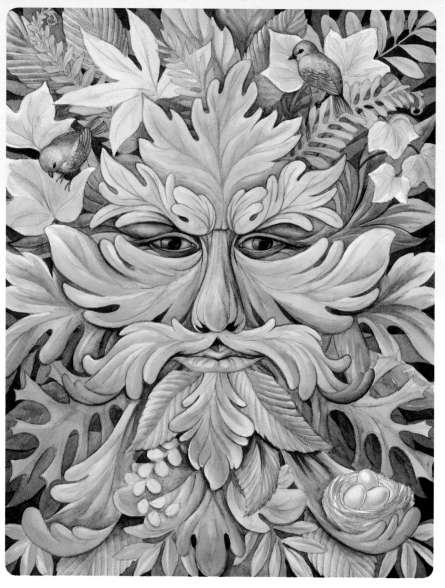

8 Using a no. 1 round, apply Viridian to the upturned mustache and beard leaves. Using the Viridian and Ivory Black mixture from Step 7, apply veins to the background leaves. Use this mixture and a no. 00 round to paint the area behind the ivy. Use a mixture of Permanent Sap Green and Ivory Black to suggest background leaves where there are empty spaces and to add details to the background leaves.

9 Using a no. 0 round, apply a dark tint of Oxide of Chromium to the ivy. With a no. 1 round, apply Indian Red to the inner part of the five-petaled leaf at the top left, blending the color outward with clear water. Let dry. Using a no. 000 round, apply Olive Green to the outer edge of this leaf and to the chin leaves. Using Permanent Sap Green loaded on a no. 000 round, add veins to these leaves. Apply Winsor Emerald around the nostrils and to the upturned parts of the beard and mustache. Use Indian Red loaded on a no. 000 round to add detail to the tendril below the chin. Add final details of Oxide of Chromium to the edges of the leaves and Permanent Sap Green to the veins.

Complete the nest following the mini demonstration on this page.

MINI DEMONSTRATION ~ *Finishing the Nest*

1 Apply Cobalt Turquoise to the eggs with a no. 00 round. Darken the shadow side of the nest with a shade of Antwerp Blue.

2 With the no. 00 round, apply Burnt Sienna to the nest following its circular shape. Use the no. 00 round to apply Cobalt Turquoise to the eggs. Let this dry briefly, then apply a darker tint of the blue to define the eggs, being careful to keep the color away from the edges of the eggs.

3 Using a no. 00 round, apply Indigo inside the nest. Rinse the brush and use it to apply Burnt Umber and Sepia to the nest following its curve.

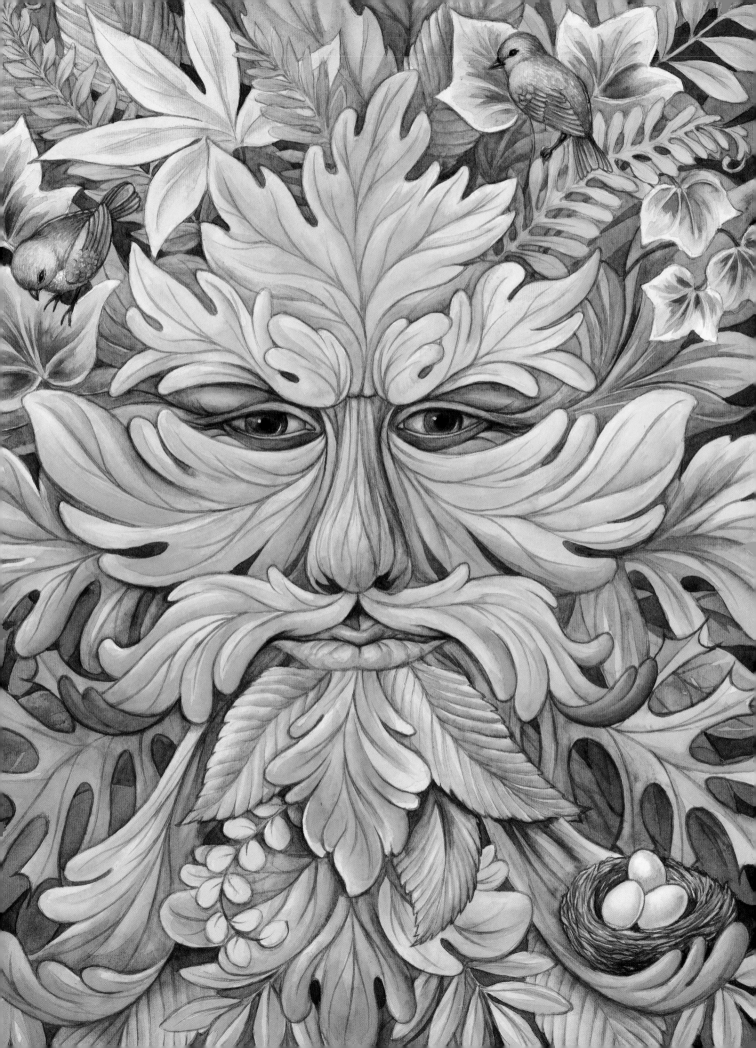

DALE, THE DWARF MINER

*This picture offers a study in opposites. Sur-
rounding the oranges and browns with blues
and greens forces you to focus on the main figure.
The yellow facets in the foreground keep the contrast
from being too stark. The most important thing to cap-
ture, however, is Dale's happy expression.*

~YOU WILL NEED~

PAINTS

Alizarin Crimson ✍ Antwerp Blue ✍ Burnt Sienna ✍ Burnt Umber ✍ Cadmium
Orange ✍ Caput Mortuum Violet ✍ Chinese Orange ✍ Cobalt Turquoise ✍
Horizon Blue ✍ Indigo ✍ Ivory Black ✍ Lemon Yellow ✍ New Gamboge ✍ Olive
Green ✍ Prussian Blue ✍ Sepia ✍ Turquoise ✍ Ultramarine Blue (Green Shade)
✍ Vermilion ✍ Viridian ✍ Winsor Emerald ✍ Winsor Violet (Dioxazine) ✍
Yellow Ochre

MATERIALS

1½-inch (38mm) sable flat brush ✍ HB lead pencil ✍ Nos. 000, 00, 0, 1 and 2 sable
round brushes ✍ Stretched watercolor paper ✍ Transferring materials from page 15

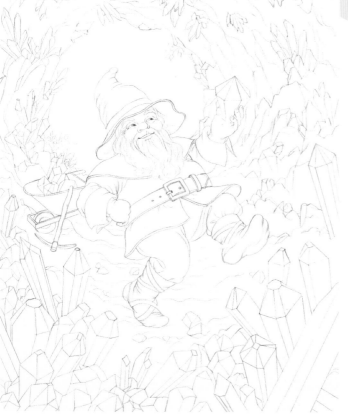

1 Sketch Dale and his surroundings with an
HB lead pencil and transfer the drawing to
stretched watercolor paper.

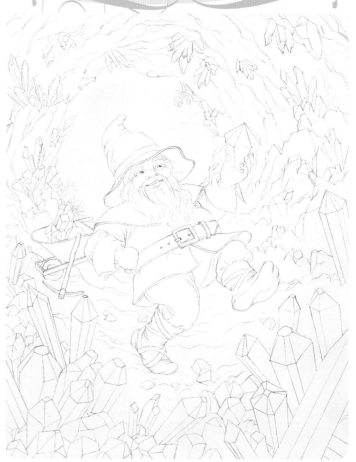

2 Wet the entire surface of the drawing using a
1½-inch (38mm) flat. Use the same brush to
paint the perimeter with a light tint of Horizon
Blue and the center with a light tint of Winsor Emer-
ald. Let this dry.

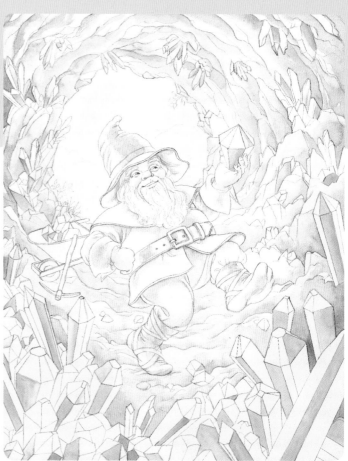

4 Using a no. 1 round loaded with Winsor Violet (Dioxazine), paint the ground behind the crystals. Apply Olive Green to the contours of Dale's face that receive less light. Using a no. 0 round, apply Ultramarine Blue (Green Shade) to the areas on his figure that are in deepest shadow. Using a no. 00 round, apply Horizon Blue to the crystal facets that receive the most light.

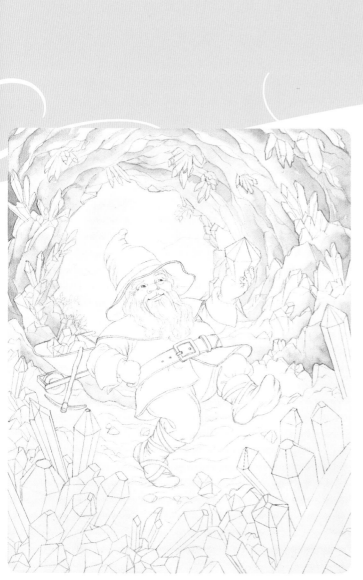

3 Using a no. 1 round loaded with Winsor Emerald, paint the background walls of the mine. Using the same brush, apply Antwerp Blue to the midground walls.

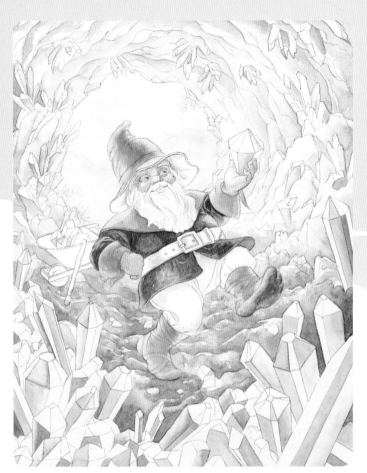

5 Create a fleshtone by mixing together Burnt Sienna and Vermilion. Wet the skin using a no. 0 round and apply the fleshtone, working wet-into-wet. Use a darker tint of the mixture on the areas of skin in shadow. Using a no. 1 round, apply Yellow Ochre to the cuffs and collar, leaving the edges lighter where they face the light. Let this dry. Using a no. 00 round, apply Cobalt Turquoise to other crystal facets, blending outward to the edges with clean water.

Using a no. 1 round, apply Caput Mortuum Violet to the ground behind the foreground crystals, Burnt Umber to the midground, and a light tint of Sepia behind that, fading towards the mine opening. Using a no. 00 round, add Olive Green to the areas of his beard and mustache in shadow. Dab a little Burnt Umber on the sole of his right boot using a no. 0 round.

Use the mini demonstration on this page to paint Dale's hat.

MINI DEMONSTRATION ~ *Painting Dale's Hat*

1 Using a no. 1 round, apply Yellow Ochre to the hat, leaving the edges lighter where they face the light. Let this dry.

2 Using a no. 1 round, apply Burnt Umber to the area underneath the brim. Use a shade tint of Burnt Sienna and the no. 0 round on the portions of his hat in deepest shadow.

3 Using a no. 0 round, apply Chinese Orange to the band of his hat, suggesting the shine of leather.

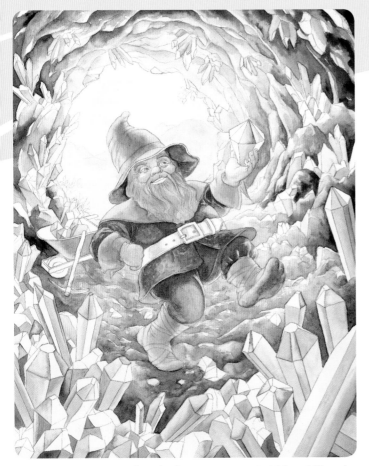

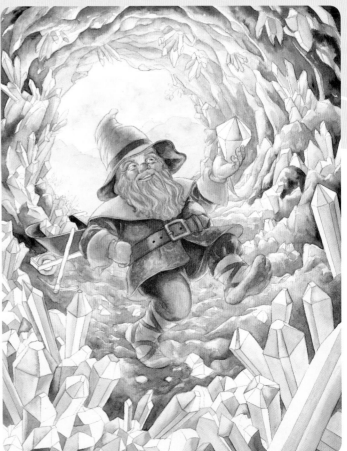

6 Using a no. 0 round, apply Chinese Orange to Dale's beard. Rinse the brush and use it to add Indigo to the wheelbarrow, blending toward its front with clean water. Using a no. 1 round, apply Burnt Umber to his pants. Use a darker shade of Burnt Sienna and the no. 0 round on the portions of his clothing that are turned farthest from the light.

Using a no. 00 round, apply Viridian to the crystal facets that receive the least amount of light and Prussian Blue to the facets that receive a medium amount of light. Apply Indigo to the crystal facets in shadow and to the ground behind the crystals. Using a no. 0 round, paint the walls of the mine with Antwerp Blue, adding Indigo before it dries.

7 Using a no. 000 round, apply Vermilion to Dale's nose and cheeks, blending away from the center with clean water. Clean the brush and use it to apply Cobalt Turquoise to his eyes. Use the same brush to apply the fleshtone mixture from Step 5 to his mouth. Using a no. 0 round, apply Chinese Orange to his belt and boot straps to suggest the shine of leather. Let this dry briefly, then apply Alizarin Crimson to the shadow areas. Using a no. 000 round, apply New Gamboge to the buckle front and Cadmium Orange to its sides. Using a no. 0 round loaded with Burnt Umber, paint the areas of the jacket that receive less light. Apply a darker tint of Yellow Ochre to the collar, sleeve cuffs and boots.

Apply Horizon Blue and darker tints of Turquoise to the shadow areas of the distant crystal facets. Apply a light tint of Indigo with a no. 00 round behind the crystal in Dale's hand and to the left side and top of the mine opening.

Using a no. 1 round, apply a light tint of Horizon Blue to the sky and Olive Green to the landscape below it. Using a no. 00 round, apply a dark tint of Sepia inside the wheelbarrow and a lighter tint on the outside. Apply a medium tint of Ivory Black over the Sepia to the corner on the right.

Mix together a darker tint of fleshtone using Vermilion and Burnt Sienna and apply it to the shadow areas of the skin using a no. 0 round.

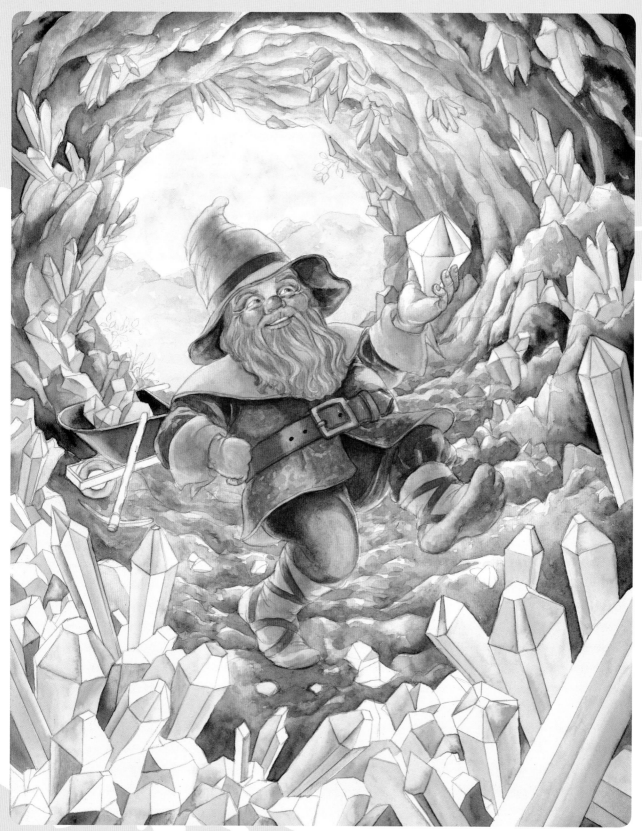

8 Using a no. 2 round, apply a light tint of Indigo to the mid- and background walls of the mine. Using a no. 00 round, apply a medium tint of Winsor Emerald and a medium tint of Turquoise to various facets of the midground crystals.

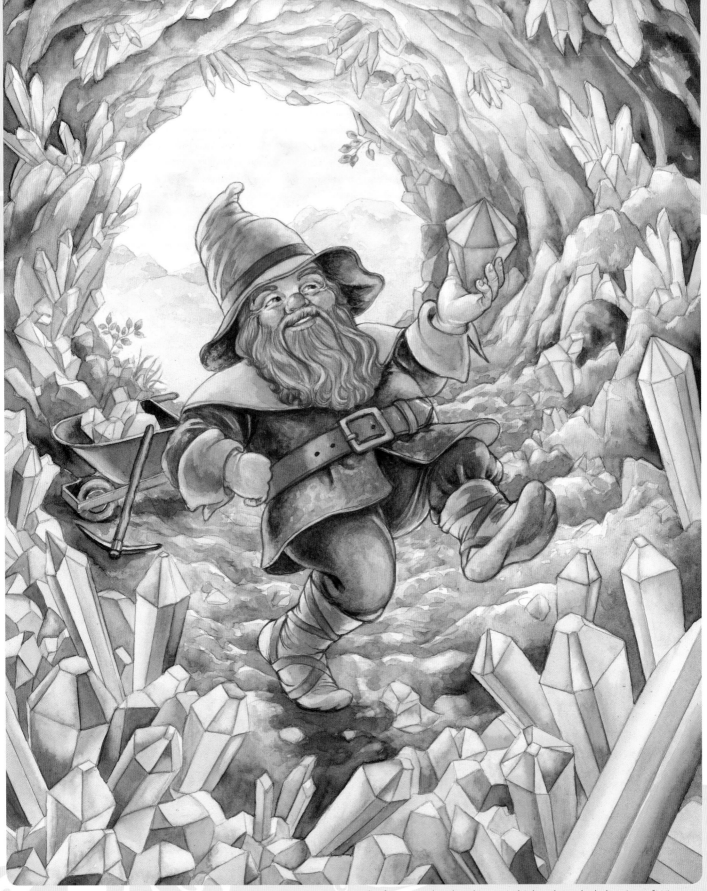

9 Using a no. 00 round, apply a dark tint of Chinese Orange to the beard. Using a no. 1 round, apply a light tint of Burnt Umber to the hat, collar and cuffs in shadow. Add a darker tint of Burnt Umber to the sole of the boot, then add a bit of Indigo as it dries.

Dip a no. 000 round in Sepia, then paint the outer edges of the figure. Using a no. 00 round, add Lemon Yellow to the smaller crystal facets in the foreground and to the one in his hand. Apply darker tints of Winsor Emerald and Viridian to the foreground facets and to the crystal he's holding. Using a no. 000 round, paint the inside of his mouth around the upper teeth. Erase the pencils lines where visible. Paint Dale's shadow with Indigo and Sepia.

DEMONSTRATION

AT HOME GNOME

Since Mr. Gnome, like so many gnomes, enjoys an after–dinner puff on his pipe, he is pictured outdoors where he won't bother anyone. Mushrooms on the lower right help keep your eyes from going off the page with the strong diagonal of the tree root. When composing pictures, it's important to place objects where they will lead the eyes through the setting. Here the tree roots lead us back to his front door.

~ YOU WILL NEED ~

PAINTS

Antwerp Blue ～ Burnt Sienna ～ Burnt Umber ～ Cadmium Red ～ Cadmium Yellow ～ Caput Mortuum Violet ～ Chinese White ～ Cobalt Blue ～ Hooker's Green ～ Indanthrene Blue ～ Indian Red ～ Indigo ～ Ivory Black ～ Lilac ～ New Gamboge ～ Olive Green ～ Oxide of Chromium ～ Payne's Gray ～ Permanent Rose ～ Permanent Sap Green ～ Raw Umber ～ Sepia ～ Vermilion ～ Viridian ～ Winsor Violet (Dioxazine) ～ Yellow Ochre

MATERIALS

HB lead pencil ～ Masking fluid ～ No. 1 acrylic round brush ～ Nos. 000, 00, 0, 1, 2 and 6 sable round brushes ～ Square masking fluid pickup ～ Stretched watercolor paper ～ Transferring materials from page 15

1 Sketch Mr. Gnome and his surroundings with an HB lead pencil, then transfer the drawing to stretched watercolor paper.

2 Using a no. 1 acrylic round, apply masking fluid to the gnome's figure, the foreground and midground mushrooms, heart-shaped oxalis and other leaves, the flowers and thimble planter. Using a no. 1 round, paint a light tint of Antwerp Blue behind the distant mushrooms and foreground tree root.

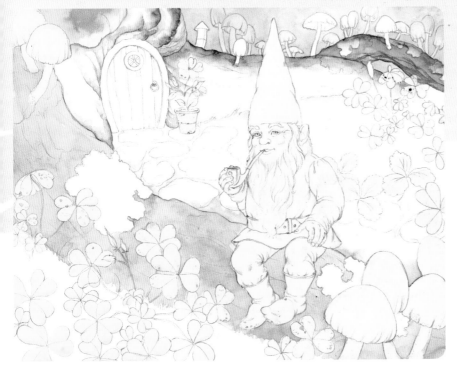

3 Using a no. 1 round, apply Caput Mortuum Violet to the top of the background tree root and let dry. Use the no. 1 round to paint the arched root in the upper right with a medium tint of Burnt Umber, being careful to paint around the lichen. Let this dry briefly then use a no. 00 round to paint the underside contours of the root with Indigo. Using a no. 2 round, apply a medium tint of Burnt Sienna to the foreground root.

4 Using a no. 2 round, paint the background grass with a light tint of Hooker's Green. Apply a darker tint of Hooker's Green to the foreground grass. With a no. 2 round, glaze the background tree root with a medium tint of Burnt Umber. Let this dry briefly then add irregular Sepia bark shapes.

Paint the bark of the foreground root following the mini demonstration on page 90.

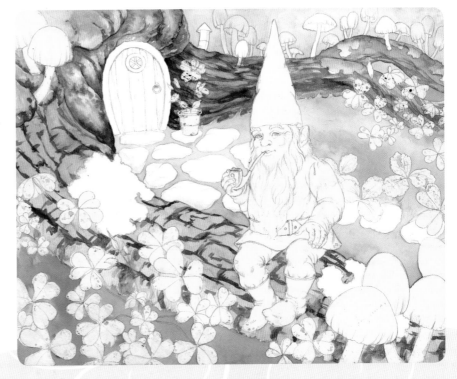

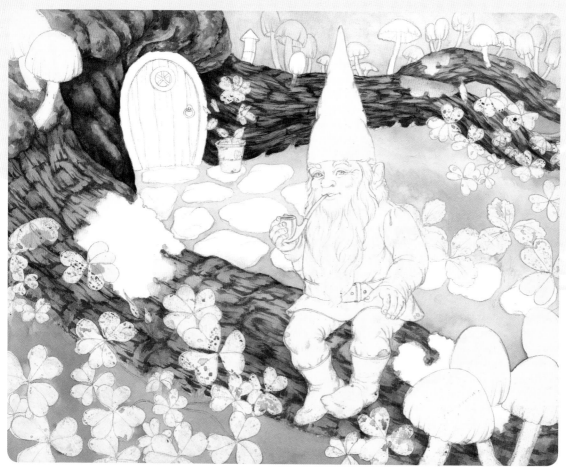

5 Using a no. 6 round, apply clear water over the foreground tree root. Let this dry briefly, then paint a mixture of Sepia and Winsor Violet (Dioxazine) to the bottom of the root with a no. 6 round. Let this dry. Using a no. 2 round, apply Indigo to the trunk contours to the left of the door and Burnt Sienna to the contours above it.

MINI DEMONSTRATION — *Painting the Bark on the Foreground Root*

1 Glaze the foreground tree root with a medium tint of Yellow Ochre with a no. 2 round and let dry. Using a no. 1 round, suggest bark with a medium-dark tint of Burnt Sienna.

2 Using a no. 6 round, apply clear water over the foreground tree root. Let this dry briefly, then using a no. 1 round, add details to the bark of the foreground root with Burnt Sienna, following its twisting formation.

3 Using a no. 00 round loaded with a medium tint of Sepia, refine the bark texure and let this dry. Use a no. 00 round loaded with a dark shade of Sepia to add details along the bark.

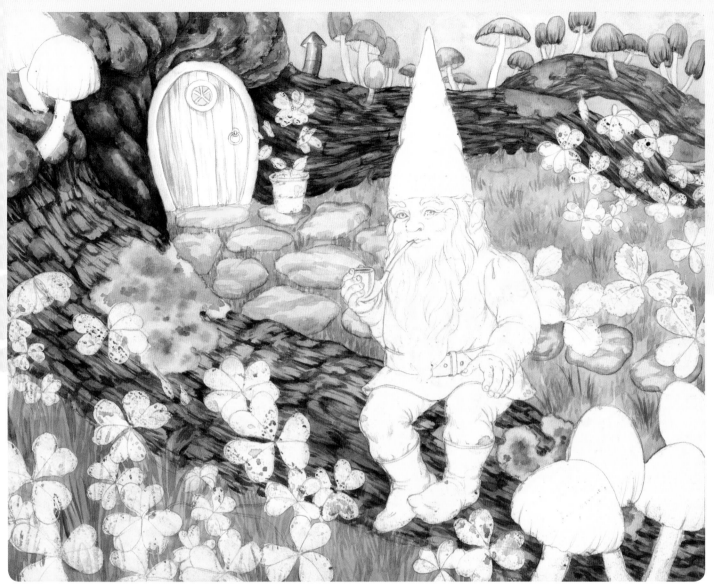

6 Dip a no. 1 round in clean water then wet the stepping stones. Mix a small amount of Indigo and Ivory Black and apply this to the stones with the no. 1 round. Let this dry briefly, then add Raw Umber around the outer edges and top contours of the stones. Let this dry.

Using a no. 0 round, apply a medium tint of New Gamboge to the doorstep and window. Load the no. 0 round with Oxide of Chromium, and, starting at the bottom, paint vertical strokes on the forest floor to suggest blades of grass.

Wet the background mushrooms using a no. 00 round. Let this dry briefly, then apply a light tint of Yellow Ochre, adding a darker tint to the areas in shadow. Let this dry briefly, then use the no. 00 round to apply strokes of Winsor Violet (Dioxazine), starting from the bottom edge of the mushroom cap and lifting upward as you work. Let dry. Wet the lichen using a no. 0 round. Use the brush to apply a mixture of Payne's Gray and Viridian to the lichen. Let this dry briefly, then apply dots of a darker tint of the two colors. Let this dry.

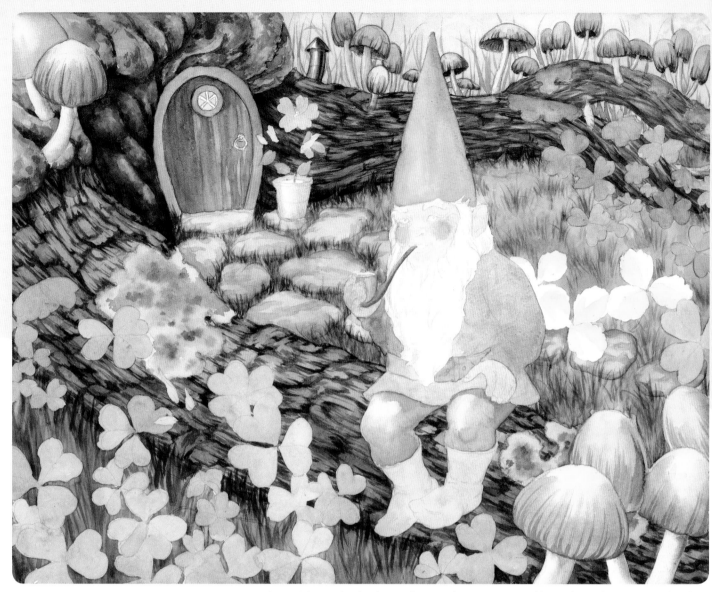

7 Mix together Viridian and Indanthrene Blue. Use this to create grasslike strokes with a no. 1 round and let dry. Apply clean water over the grass to soften the effect. After this dries, add a few more scattered strokes for variety, making the strokes thinner as you move from the foreground to the background. Using a no. 2 round, wet the door, then brush on Indanthrene Blue. Let this dry briefly, then suggest the wood's grain with wavy strokes of Indian Red.

Paint the distant mushrooms with a layer of Yellow Ochre and a no. 0 round. Let this dry briefly, then add Winsor Violet (Dioxazine). Paint the undersides of the mushroom caps with a no. 00 round and a mixture of Winsor Violet (Dioxazine), Indanthrene Blue and Sepia. Let this dry.

Remove the masking fluid with a square masking fluid pickup. Using a no. 2 round, apply New Gamboge to the sunlit leaves behind the gnome. Using a no. 0 round, apply a medium tint of Cobalt Blue to the door trim. Wet the gnome's cheeks, and apply Vermilion with a no. 000 round, blending out with clean water. Create a flesh-tone by mixing Burnt Sienna with a tiny amount of Vermilion and apply this to the gnome's face and hands with a no. 1 round. Use a no. 2 round to apply a medium tint of Cobalt Blue to the shirt. Let this dry briefly, then apply darker tints of Cobalt Blue to the shadow areas.

Using a no. 2 round, apply a light tint of Olive Green to the oxalis. With the same brush, wet the gnome's cap then apply Cadmium Red, leaving less color where the light hits it. Use a no. 2 round to paint the belt and boots Yellow Ochre.

Using a no. 000 round, paint the flower buds New Gamboge and let this dry. Using a no. 00 round, apply Yellow Ochre to the buds in shadow. Using a no. 000 round, apply a light tint of Sepia to his pipe, except for the top rim. Let this dry. Using the no. 000 round, apply a medium tint of Burnt Sienna to the right side of the pipe's bowl and to the right side of the pipe stem.

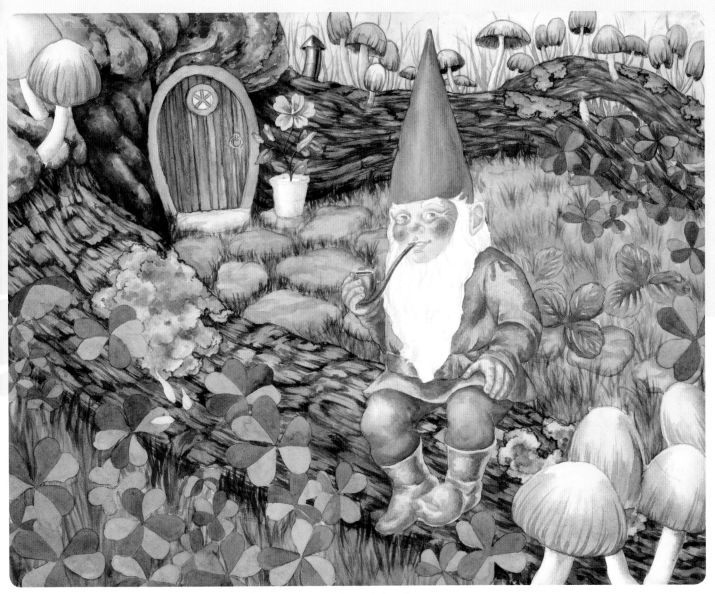

8 Using a no. 2 round, paint sections of the oxalis Permanent Sap Green. Soften the colors by brushing on clean water over the oxalis. Using a no. 1 round, apply a light tint of Raw Umber to the shadows of the belt and boots. Let this dry briefly, then apply Burnt Sienna to the darkest shadows. Using a no. 000 round, apply a mixture of Indigo and Sepia to the outer edges of the lichen. Soften the edges with clean water, blending away from the edge.

Add a darker tint of Cobalt Blue to the shadow areas of the shirt with a no. 1 round. Apply a darker tint of the fleshtone mixture from Step 7 to the face and hands using a no. 1 round. With a no. 0 round, paint the cheeks and nose Permanent Rose, leaving highlights of lighter color and a touch of Vermilion nearest each highlight. With a no. 2 round, apply a medium tint of Permanent Rose to his cap. Using a no. 000 round, paint his eyes with a medium tint of Cobalt Blue. Refine the pipe by applying a darker shade of Sepia along the outer edge with a no. 000 round.

Using a no. 0 round, add Viridian to the lichen and Indigo to the stone path. Apply Olive Green to the leaves of the potted plant with a no. 00 round. Let this dry briefly, then apply Oxide of Chromium to the leaves' contours in shadow. Paint the potted plant's flower with Lilac and Winsor Violet (Dioxazine) and its buds with New Gamboge, using a no. 1 round.

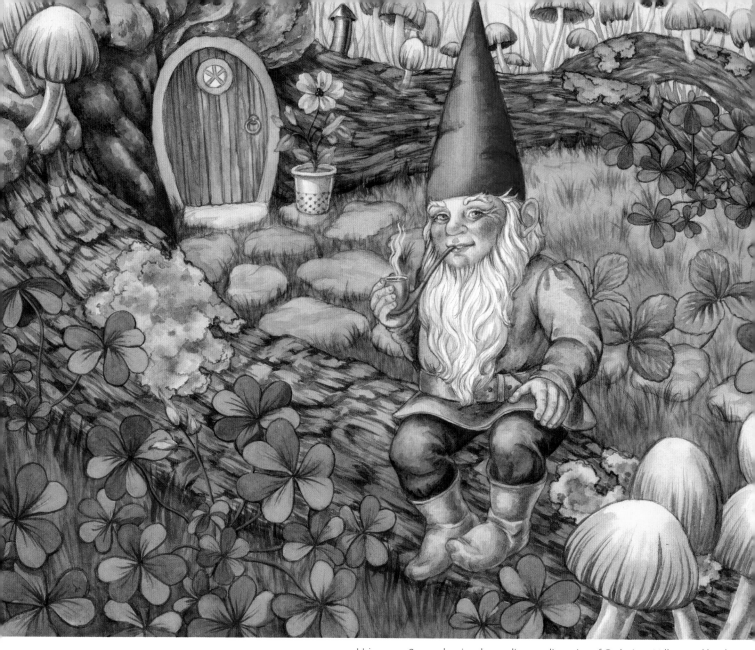

9 Using a no. 2 round, paint the oxalis a medium tint of Cadmium Yellow and let dry. Mix together a medium-dark shade of Viridian and Indanthrene Blue and apply this to the outer edges and center veins of the oxalis with a no. 000 round. Use a no. 00 round to apply a medium tint of Sepia to the foreground mushrooms. With a no. 000 round, apply Yellow Ochre to the oxalis stems, then apply Burnt Umber to the areas of the stems in shadow.

Using an HB lead pencil, draw the waves of his beard, then use a no. 00 round to add variety to strands of hair in the beard and eyebrows with a medium tint of Ivory Black. Using a no. 0 round, apply a light tint of Ivory Black to the contours of the beard in shadow. Using the HB lead pencil, draw facial features, add wrinkles and define the contours of his face and hands, making sure that the corners of the mouth show a hint of a smile. Using a no. 000 round, paint the smoke trailing from his pipe with Chinese White thinned with water.

DEMONSTRATION
PANRA, WOOD ELF

Panra's pose lends an air of mystery to the composition. The mood is enhanced by the movement of her hair, which is repeated in the branches behind her. She seems lost in thought as she stares into the distance and her elegant attire tells us she is an elf of a high order. The setting was designed to be a peaceful retreat where an elf, or anyone, could go to be alone.

~YOU WILL NEED~

PAINTS

Alizarin Crimson ⌇ Antwerp Blue ⌇ Burnt Sienna ⌇ Burnt Umber ⌇ Cadmium Red ⌇ Cadmium Yellow ⌇ Cadmium Yellow Pale ⌇ Cadmium Yellow Deep ⌇ Caput Mortuum Violet ⌇ Cerulean Blue ⌇ Chinese White ⌇ Cobalt Blue ⌇ Cobalt Turquoise ⌇ Hooker's Green ⌇ Indian Red ⌇ Indigo ⌇ Lilac ⌇ New Gamboge ⌇ Olive Green ⌇ Oxide of Chromium ⌇ Payne's Gray ⌇ Permanent Sap Green ⌇ Quinacridone Red ⌇ Sepia ⌇ Ultramarine Blue (Green Shade) ⌇ Viridian

MATERIALS

1½-inch (38mm) sable flat brush • HB lead pencil • Nos. 000, 00, 0, 1, 2 and 3 sable round brushes ⌇ Stretched watercolor paper ⌇ Transferring materials from page 15

1 Sketch the drawing with a pencil and transfer it to stretched watercolor paper. Use an HB lead mechanical or wood pencil to draw over the transferred sketch if it's very faint. Most of these lines will disappear as you apply paint.

2 Wet the entire picture using a 1½-inch (38mm) flat. Mix Lilac and Alizarin Crimson and apply a light tint of this over the entire drawing. Apply another layer of the mixture behind her head. Let this dry.

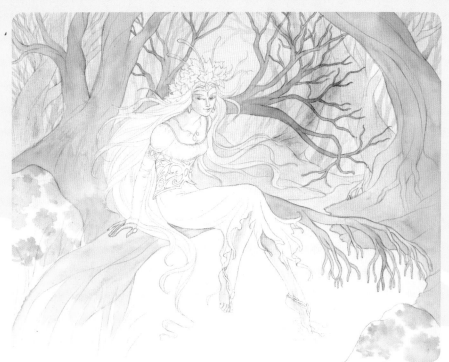

3 Rewet the painting, then apply a light tint of Cerulean Blue. Let this dry briefly, then use a medium tint of Cerulean Blue and a no. 1 round to paint the background trees. Wet the stream and use a no.1 round to apply a light tint of Cobalt Turquoise to the top, blending it into the white paper by applying clean water as you move downward. Use the no.1 round to apply Cerulean Blue to the land behind Panra. Let this dry and apply Olive Green to the foreground trees using a no. 2 round. Mix a light tint of Olive Green and Burnt Sienna and use a no. 1 round to apply this the shadow areas of the skin.

Wet the rocks with a no. 1 round. Let this dry briefly, then drop in a mixture of Viridian, Payne's Gray and Chinese White to suggest lichen.

4 Using a no.1 round, wet the hair and leaves in Panra's headdress and, working wet-into-wet, apply a light tint of Antwerp Blue to the areas in shadow. With a no. 1 round, apply a light tint of Burnt Umber to the shadow areas of the dress. Wet the stream, let it dry briefly, then use a no. 3 round to apply horizontal streaks of Ultramarine Blue (Green Shade). Use a no. 1 round to apply details to the background trees and earth with the Ultramarine Blue (Green Shade). With the no.1 round, apply a medium tint of Olive Green to the midground trees and contours of the earth on the right. Add Burnt Umber to the right side of the tree on the right.

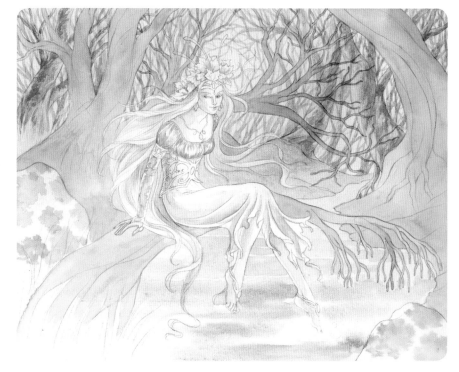

5 Using a no. 1 round, apply patches of a light tint of Hooker's Green to the shadow areas of the background trees. Rinse the brush, then add a medium tint of Burnt Umber to her hair. Use a no. 00 round to apply Indigo around the lichen on the rocks. Apply a light tint of Burnt Umber to the foreground tree with a no. 1 round.

Follow the mini demonstration on page 98 to create the headdress.

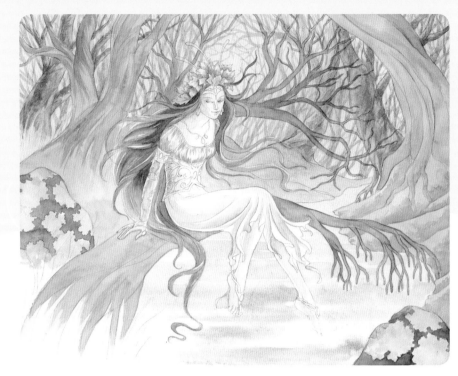

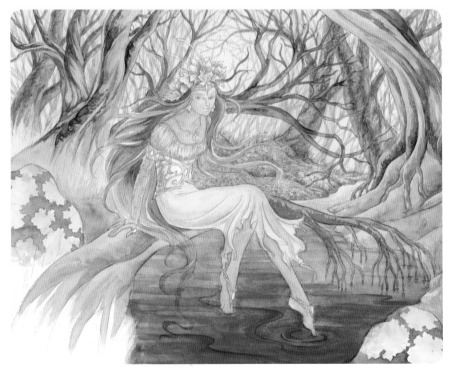

6 Use a no. 1 round to suggest twisting bark on the midground tree on the left with Sepia. To the midground tree on the right, apply a light tint of Cobalt Blue with a no. 2 round. Let this dry briefly, then add Burnt Umber. Add variety to the earth under these trees with Cerulean Blue and a no. 1 round. Use the same brush to add details to the background trees, earth and grasses with a medium-dark tint of Cerulean Blue.

With a no. 1 round, apply Ultramarine Blue (Green Shade) in wavy patterns to the water in the foreground. When dry, apply ripples around Panra's toes with a dark tint of Ultramarine Blue (Green Shade), then blend the inner edges with clean water. Use a no. 00 round to add a medium tint of New Gamboge to her dress, headdress and feet ornaments.

Create a fleshtone by mixing Burnt Sienna with a bit of Cadmium Red. Apply a medium tint of this to Panra's skin using a no. 1 round.

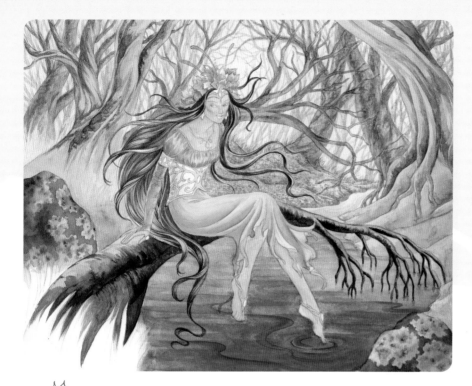

7 Using a no. 1 round, apply a mixture of Cadmium Yellow Pale and Permanent Sap Green to Panra's dress. Let this dry. Using a no. 1 round, apply a dark tint of Sepia to the foreground tree in arcs, blending the edges with clean water. Add Burnt Umber with a no. 00 round to the twists and turns of her hair. Working wet-into-wet, apply spots of Indigo and Viridian to the lichen. When the shine is gone, apply dots of a darker tint of Indigo and let this dry. Apply a medium-dark tint of Indigo to the rocks. Apply a darker tint of Indigo to the shadows.

Follow the mini demonstration on page 99 to paint Panra's face.

MINI DEMONSTRATION — *Painting the Headdress*

1 Add Permanent Sap Green to her headdress using a no. 000 round.

2 Using a no. 000 round, apply arcs of Cadmium Yellow Pale to the leaves and gold in her headdress.

3 Using a no. 000 round, apply Cadmium Yellow Deep inside the headdress. Add Sepia details to her hair and headdress using a no. 000 round.

4 Apply a mixture of Cadmium Yellow Pale and Permanent Sap Green to the jewels in the headdress, leaving a white highlight to make the jewel sparkle. Refine the headdress with Cadmium Yellow Deep and a no. 000 round.

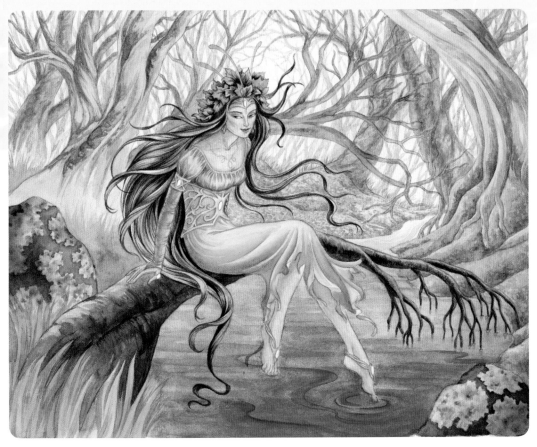

8 Using a no. 2 round, apply Oxide of Chromium to the ground on the right, dabbing it on for a mottled effect. Apply, with a no. 1 round, a mixture of Permanent Sap Green and Ultramarine Blue (Green Shade) to the grasses on the foreground at left. Below the tree behind Panra, use a no. 1 round to apply Oxide of Chromium to suggest a spray of grass. Using a no. 000 round, apply Payne's Gray around the lichen to suggest curled edges.

Using a no. 000 round, apply Cadmium Yellow Deep inside the scroll pattern at the waist, and to her feet ornaments and earrings. Add Sepia details to her hair using a no. 000 round. Mix a darker shade of Cadmium Yellow Pale and Permanent Sap Green and apply this to the dress. Let this dry briefly, then apply a light tint of Caput Mortuum Violet to the shadows of the folds.

MINI DEMONSTRATION — *Painting the Face*

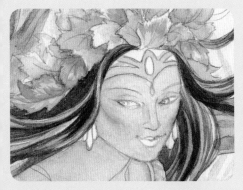

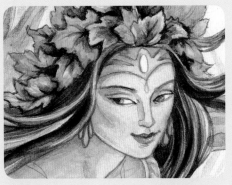

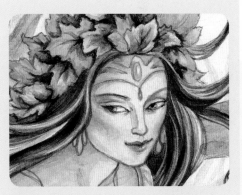

1 Wet Panra's cheeks with a no. 0 round. Let this dry briefly, then apply a medium tint of Quinacridone Red. Let this dry.

2 Using a no. 1 round, apply a darker shade of the fleshtone mixture from Step 6. Apply Alizarin Crimson to her lips using a no. 000 round. Use a clean no. 000 round to apply Permanent Sap Green to the eyes. With a no. 000 round, apply a darker shade of the fleshtone mixture to her eyelids and under her eyes. Paint the eyebrows with Burnt Umber. Let this dry.

3 Use a no. 000 round to apply a light tint of Olive Green to Panra's eyelids. Clean the brush, then refine the eyes with a mixture of Cadmium Yellow and Viridian. Apply a darker shade of the fleshtone to the areas in shadow. Use a no. 000 round to outline the eyes in Sepia. Add Quinacridone Red to her cheeks, blending out with clean water.

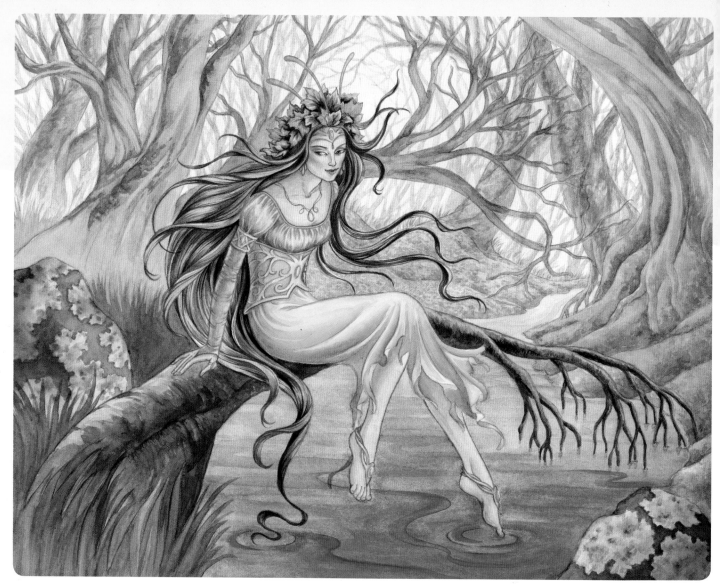

9 Use a no. 1 round to apply a light tint of Ultramarine Blue (Green Shade) to the midground trees. Apply a mixture of Permanent Sap Green and Ultramarine Blue (Green Shade) to the grasses in the foreground and behind Panra with the no. 1 round.

Apply a darker tint of the fleshtone to the darkest shadows of the skin with a no. 00 round. Using a no. 00 round, apply Indian Red to the left side of the waist ornament. Apply a mixture of Cadmium Yellow Pale and Permanent Sap Green to the jewels in the waist and feet ornaments, ring and necklace, being sure to leave white highlights in the stones. Add Ultramarine Blue (Green Shade) ripples to the hair in the water with the no. 00 round.

10 Using a no. 0 round, apply a dark tint of Sepia to the tree behind the foreground grasses at the left. Using a no. 000 round, create bubbles in the water by lifting the outer edge with clean water, then use clean water to blend the bubbles' edges.

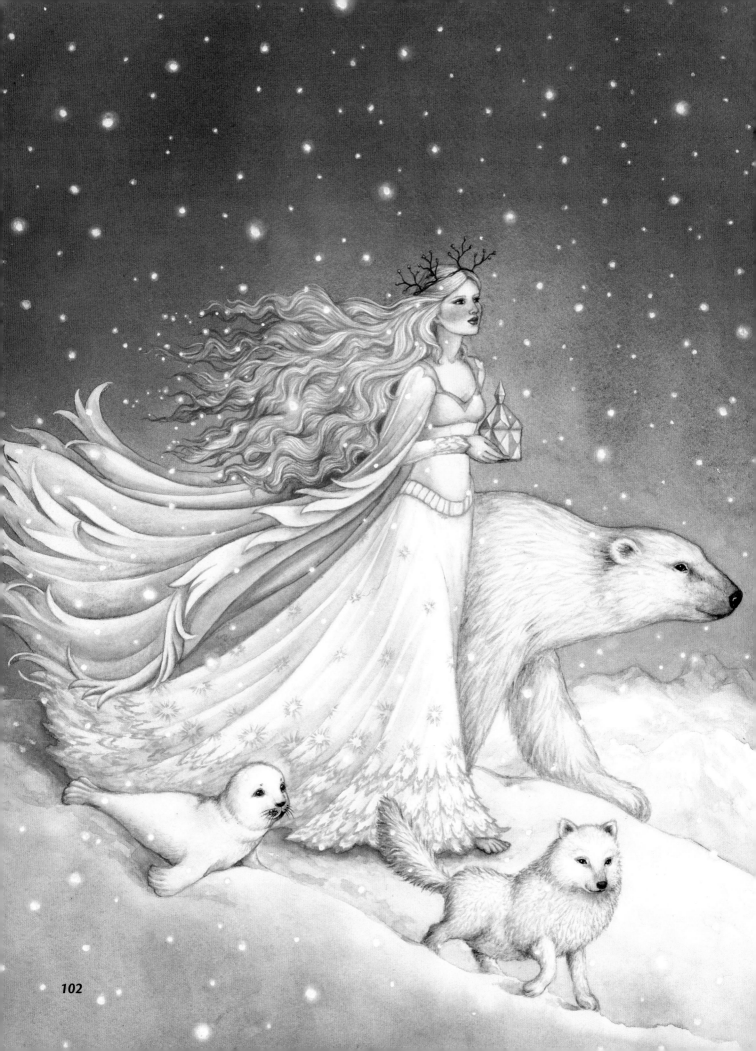

ELVEN REALMS

I N THIS CHAPTER, TWO VERY DIFFERENT TYPES OF ELVES SHOW A BIT OF THEIR WORLDS. First, Christmas elves are at work, putting the finishing touches on a toy for Santa's sleigh. Their impish expressions and amusing attire show they are not only skillful, but also like to have fun. There's no doubt that after the paint dries, they'll give the rocking horse a test ride. Take note how the forelegs of the horse, the ceiling beams and the slant of the brush held by the elf on the right all draw your eyes to the faces of the horse and elf.

In the second scene, an elven prince and princess are on a stroll in the midst of their subjects. Though the tranquil surroundings are rendered in great detail and contain a number of miniature scenes worth exploring, the large sweeps of their capes always lead your eyes back to the private glance they share.

CHRISTMAS ELVES AT WORK

Elves are not simply cute; they are also great artisans. Here they happily put the finishing touches on a blue rocking horse that's set against the warm colors of their workshop. Ceiling beams and window-panes add texture and a prominent perspective, while the decorative details become like icing on the cake. By building layers of color and texture, you can achieve the rustic look of the wood surfaces.

~ YOU WILL NEED ~

PAINTS

Alizarin Crimson ~ Burnt Sienna ~ Burnt Umber ~ Cadmium Orange ~ Cadmium Red ~ Cadmium Yellow ~ Chinese Orange ~ Chinese White ~ Cobalt Blue ~ Cobalt Turquoise ~ Hooker's Green ~ Indanthrene Blue ~ Indian Red ~ Indigo ~ Ivory Black ~ New Gamboge ~ Olive Green ~ Payne's Gray ~ Permanent Rose ~ Permanent Sap Green ~ Quinacridone Red ~ Raw Umber ~ Sepia ~ Viridian ~ Yellow Ochre

MATERIALS

HB lead pencil ~ Masking fluid ~ Nos. 000, 00, 0, 1, 2 and 3 sable round brushes ~ No. 2 acrylic bristle brush ~ Paper towel ~ Stretched watercolor paper ~ Transferring materials from page 15

1 Sketch the drawing with a pencil then transfer it to stretched watercolor paper using an HB lead pencil and transfer paper.

2 Mix a small amount of Burnt Umber with even less Ivory Black and Yellow Ochre. Using a no. 1 round, paint between the beams. Use a no. 2 round to apply a light tint of Sepia to the back wall. With a no. 1 round, apply a darker tint of Sepia to the areas of the wall in shadow.

3 Mix Burnt Sienna with a bit of Yellow Ochre and Sepia and apply this to the bottoms of the ceiling beams, the mantel, door and the windowpanes with a no. 1 round. Let this dry. Mix Sepia with a little Burnt Umber and apply this to the sides of the ceiling beams and to the beam on the back wall with a no. 1 round. Let this dry briefly. Add subtle streaks of the same mixture to the beams, suggesting the grain of wood using a no. 3 round. With the Sepia and Burnt Umber mixture and using a no. 1 round, apply it to the ceiling.

4 Using a no. 2 round, apply a pale tint of Indigo to the entire background and let dry. Dilute this mixture and apply it to the floor, keeping it lighter near the fireplace.

With a no. 0 round, apply a medium tint of Viridian mixed with Ivory Black to the toys on the mantel. With a no. 0 round, paint the fronts of the logs a very light tint of Indigo. Mix Indanthrene Blue with a hint of Viridian and apply this to the top of the windowsill with a no. 1 round. With a no. 0 round, apply a light tint of Payne's Gray to the wall in the background, making it darker in the areas behind the toys and the firewood.

Follow the mini demonstration on page 107 to paint the garland.

5 Using a no. 1 round, apply a medium-dark tint of Burnt Sienna to the bottoms of the ceiling beams and let dry. With the no. 1 round, apply a medium-dark shade of Sepia to the sides of the beams. Let this dry briefly, then add the texture of grain to the beams using a no. 000 round loaded with a dark tint of Sepia. Using a no. 1 round, apply a light tint of Yellow Ochre to the ceiling, making it darker in the areas closest to the back wall and let dry.

Using a no. 000 round, add short streaks of a dark tint of Burnt Sienna to suggest the grain of the beams. Let this dry.

Mix together a light tint of Burnt Umber and Ivory Black. Using a no. 1 round, apply this mixture to the beam along the back wall, making it darker at the top and lighter at the bottom.

6 Using a no. 000 round, paint the grain of the floorboards with a medium tint of Burnt Sienna. Add a few strokes of Sepia for more detail. Let dry. Using a no. 1 round, apply clear water to set the color.

MINI DEMONSTRATION — *Painting the Garland*

1 Using a no. 1 round, apply a medium tint of Hooker's Green to the garland. With a no. 1 round and a mixture of Alizarin Crimson with a hint of Indigo, paint the bows.

2 Using a no. 1 round, apply a medium tint of Olive Green along the center of the garland to suggest leaves and let dry. Wet the ornaments hanging from the garland. Let this dry briefly, then use a no. 000 round to apply Cobalt Blue, Permanent Rose and Yellow Ochre, following the shape of the balls and leaving highlights. Let this dry.

 Mix Alizarin Crimson with a hint of Indigo and apply this to the bow's contours in shadow.

3 Using a no. 000 round, paint the leaves on the outer edges of the garland with Hooker's Green.

4 Using a no. 000 round, apply more detail to the garland with a darker tint of Permanent Sap Green.

5 Using a no. 00 round, apply a medium-dark tint of Alizarin Crimson to the bows on the garland.

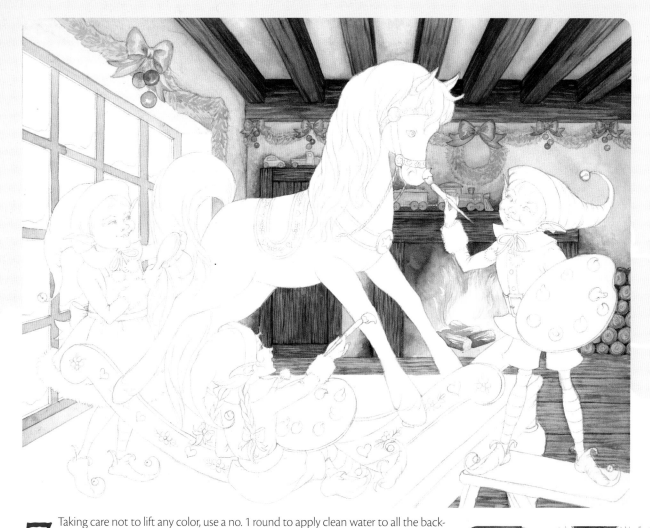

7 Taking care not to lift any color, use a no. 1 round to apply clean water to all the background wood surfaces. This will set the layers of color.

With the no. 1 round, apply a light tint of Indian Red curves to suggest flames and let dry. Then, apply a dark tint of Indigo around the fire, beginning at the outer edges of the fireplace and working toward the center with lighter tints of Indigo. With a no. 0 round, apply a medium tint of Indigo around the fireplace in the areas in shadow.

Using a no. 000 round, apply a dark tint of Burnt Sienna to suggest the texture on the doors and mantel. Let this dry.

Mix together a light tint of Burnt Sienna and Ivory Black and apply it in horizontal strokes to the floorboards. Charge in Burnt Sienna as you get closer to the foreground. Let this dry.

Mix Indigo with a hint of Sepia and, using a no. 1 round, refine the background wall, carefully working around the elf's hat, toys, mantel and door.

Apply a layer of Yellow Ochre over the stacked firewood with a no. 1 round. Create the rings with a medium tint of Raw Umber mixed with a bit of Indigo. Refine the individual logs with a no. 000 round and a mixture of Indigo and Sepia.

Paint the wood in the fireplace with a mixture of Sepia and a bit of Yellow Ochre, using this to suggest wood grain. Blend the edges with water.

Mix Yellow Ochre with some Indigo and paint the wheels on the background train with a no. 000 round.

Detail of the Fire

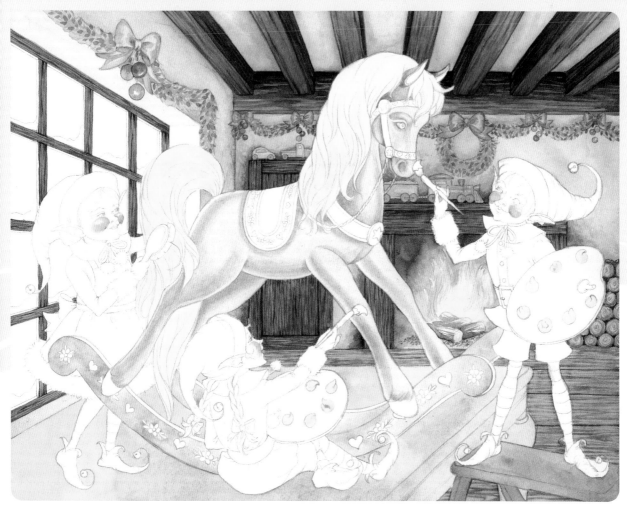

8 Using a no. 00 round, paint the windowpanes a dark tint of Burnt Sienna and let dry. Add the look of wood grain with a no. 000 round loaded with dark shades of Burnt Sienna and Sepia. Using a no. 0 round, add New Gamboge to the bottom of the fire, blending it into the Indian Red with clean water. Using a no. 000 round, paint ashes with a medium tint of Ivory Black.

With the no. 2 acrylic brush, apply masking fluid to the colors on the elves' palettes. Wet the cheeks of all the elves with a no. 0 round. Let this dry briefly, then apply Cadmium Red with a no. 000 round. Blend outward with clear water on the same brush.

Mix Yellow Ochre with a small amount of Burnt Sienna. Apply this to the worktable with a no. 1 round and let dry.

Using the no. 1 round, paint the stepladder with a medium tint of Indian Red.

To paint the rocking horse, follow the mini demonstration on page 112.

Detail of the Fire and Ashes

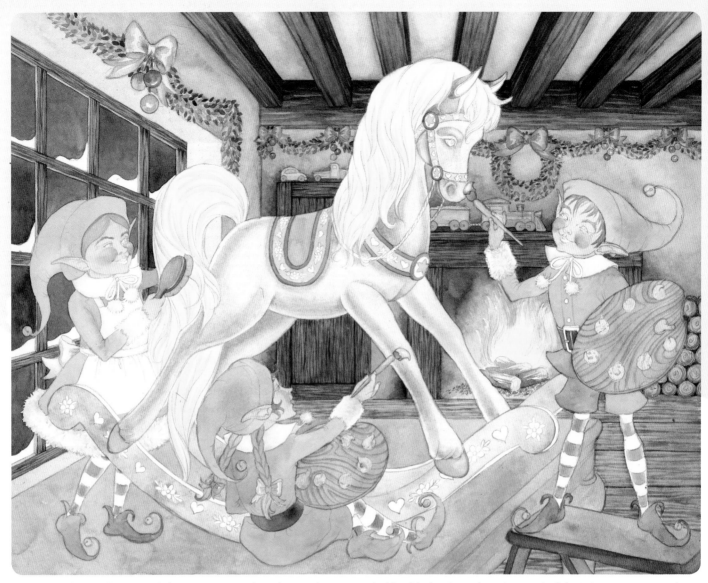

9 Apply a medium tint of Chinese Orange to the palettes using a no. 0 round. Let dry. Paint wavy lines on the palettes with a mixture of Chinese Orange and Burnt Umber. Using a no. 000 round loaded with clean water, blend one edge of the lines for a more natural look. Use a no. 1 round to apply a medium tint of Yellow Ochre to the hairbrush and paint brushes. With a no. 000 round, apply a darker tint of Yellow Ochre to the hair brush handle, then add Burnt Sienna to the shadow area of the hair brush and to the bristles of the paint brushes. Apply Cobalt Blue to the paint on the paint brushes with a no. 000 round.

Mix a bit of Ivory Black into a small amount of Indian Red. Dilute this to a medium shade, and, using a no. 0 round, apply it to the parts of the stepladder in shadow.

Wet every other stripe of the elves' leggings with clean water and a no. 000 round. Pat out the excess water with a paper towel and apply Quinacridone Red to the center of the stripes, blending to plain paper at each side of the leggings where they receive light. Using a no. 000 round, apply New Gamboge to the bells on their shoes and caps. Paint the bows in the middle elf's hair Quinacridone Red using a no. 00 round.

Using a no. 000 round, paint the harness and saddle with Cadmium Yellow. Clean the brush, then apply Yellow Ochre to the middle of the saddle and let dry. With a clean no. 000 round, apply Permanent Sap Green to the harness and saddle trim.

Mix a light tint of Ivory Black and Burnt Umber. Using a no. 2 round, apply this to the back and side walls. Using a no. 1 round, apply a darker shade of Yellow Ochre to the worktable and let dry.

Using a no. 1 round loaded with a light tint of Indigo, paint the area inside the window frame and let dry.

Using a no. 0 round, paint the windows a dark shade of Indanthrene Blue.

To paint the elves' faces and clothes, follow the mini demonstration on page 111.

MINI DEMONSTRATION ~ *Painting the Elves*

1 Create a fleshtone by mixing New Gamboge, Burnt Sienna and a bit of Cadmium Red. Use a no. 0 round to apply a light tint of this over the elves' skin. Let this dry briefly, then apply a darker tint of the mixture to the areas in shadow.

Using a no. 0 round, apply a light tint of Cobalt Turquoise to the contours of the elves' collars, cuffs, pompoms and hem. Wet the elves' caps. Let this dry briefly, then apply a medium tint of Permanent Sap Green using a no. 1 round. Let this dry briefly, then paint a darker tint to areas in deepest shadow. Do the same for the rest of the elves' outfits and shoes.

2 Work a darker tint of Permanent Sap Green into the areas of the outfits in shadow. Wet the cheeks of the elves. Using a no. 000 round, apply a medium tint of Quinacridone Red in an arc, leaving highlights. Using a no. 0 round, refine the hair of the three elves with Chinese Orange. Let dry. Using a no. 000 round, apply a darker shade of Chinese Orange to vary the strands of hair. Using a no. 000 round, apply Permanent Sap Green to the elves' eyes.

3 Using a mechanical or lead pencil containing an HB lead, redraw the outer edges of the foreground characters.

MINI DEMONSTRATION ~ *Painting the Rocking Horse*

1 Mix a medium tint of Cobalt Blue and Chinese White. Using a no. 1 round, paint the rocking horse and let dry. Apply a darker shade of this mixture to the areas in shadow. Mix a pale tint of Yellow Ochre and Chinese White and apply it to the mane and tail with a no. 1 round.

2 Using a no. 1 round, apply a darker shade of the Yellow Ochre and Chinese White mixture to the horse's mane and tail.

3 Wetting a section at a time, use a no. 1 round to apply a medium-dark tint of Cobalt Blue to the rocking horse. Let this dry briefly, then apply a dark shade of Cobalt Blue to the areas in shadow.

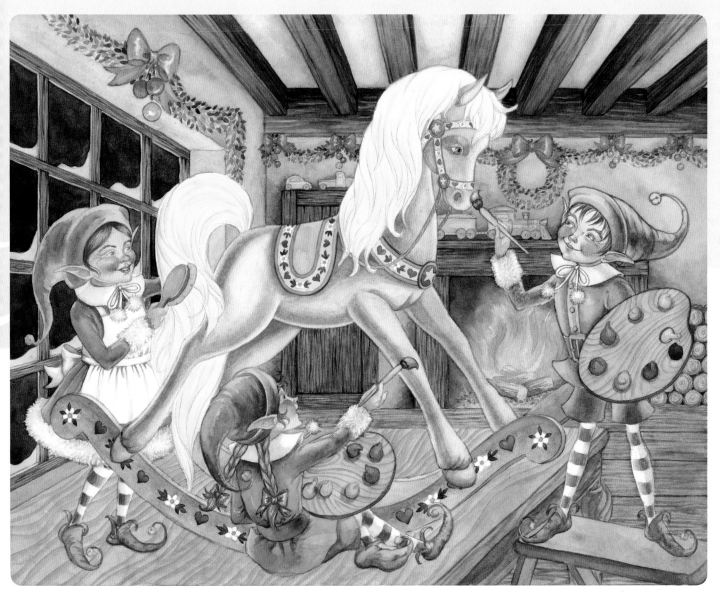

10 Using a no. 0 round, paint the windows a dark tint of Indigo. Mix Yellow Ochre with small amounts of Burnt Sienna and Chinese Orange. Using a no. 000 round, paint the grain of the worktable. Clean the brush, then blend the right edge of the grain lines into the tabletop. Paint the details on the rocking horse using Quinacridone Red, Permanent Sap Green and Cadmium Orange using the no. 000 round. Leave the flowers the white of the paper.

Paint the colors on the palettes using medium tints of New Gamboge, Cadmium Orange, Quinacridone Red, Cobalt Blue, Olive Green, Permanent Sap Green and Ivory Black. Using a no. 000 round, add darker tints of the colors to the areas in shadow. Let this dry. Using a no. 000 round, apply a medium-dark shade of Indigo around the colors to suggest a shadow.

Using a no. 000 round loaded with Indigo, paint the folds in the apron. Let this dry briefly, then apply a darker shade of Indigo to the deepest folds.

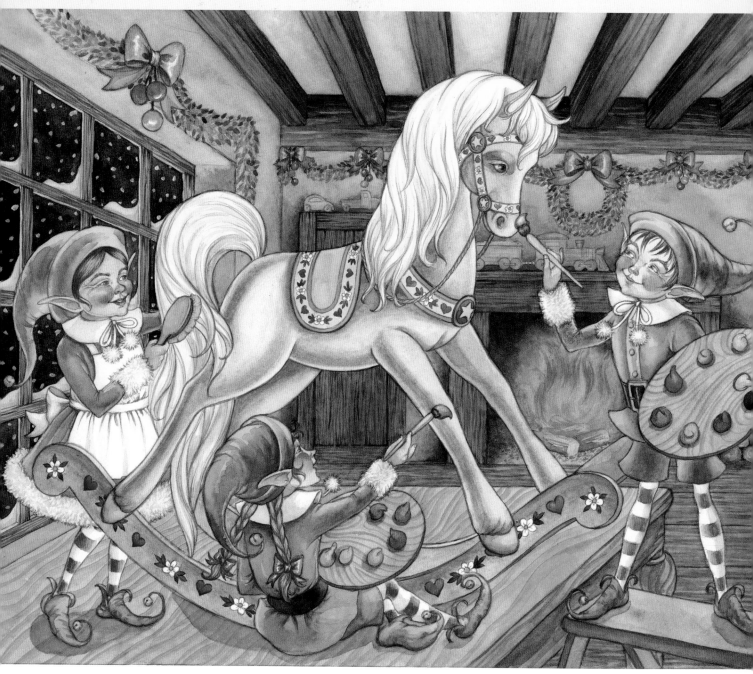

11 Carefully apply clean water over the garlands using a no. 0 round. Using the no. 0 round, apply Ivory Black to the belts of the elves, blending toward the light with clean water. Paint the buckle with Yellow Ochre. Create a shadow on the bells on the elves' shoes and caps with Cadmium Orange.

Using a no. 2 round, apply a light tint of Indigo over the background walls and wood, being careful not to lift color. This will tone down the background and make the foreground seem closer. Using a mechanical or lead pencil containing an HB lead, redraw the outer edges of the horse, adding strands of hair to the mane and tail. Add New Gamboge to the contours of the mane and tail with a no. 00 round. Use this brush to add a darker tint of Yellow Ochre to the areas of the mane in shadow.

Apply a medium-dark tint of Indigo behind the elves and rocking horse to create their shadows using a no. 0 round.

ELVEN WOODLAND

Since elves are the dominant characters in this demonstration, they are dressed in rich colors setting them apart from the pale, light-filled forest behind them and the other characters. The composition evolved by drawing sweeping curves meant to encircle the figures and draw your eyes to their happy faces. Out of reverence for the world the Elven Prince and Princess protect, the dwarf and gnomes bow and the sprites salute them.

~YOU WILL NEED~

PAINTS

Alizarin Crimson ⚬ Brown Madder ⚬ Burnt Sienna ⚬ Cadmium Red ⚬ Cadmium Yellow ⚬ CAdmium Yellow Deep ⚬ Caput Mortuum Violet ⚬ Chinese Orange ⚬ Chinese White ⚬ Cobalt Blue ⚬ French Ultramarine ⚬ Hooker's Green ⚬ Indanthrene Blue ⚬ Indian Red ⚬ Indigo ⚬ Ivory Black ⚬ Olive Green ⚬ Oxide of Chromium ⚬ Payne's Gray ⚬ Permanent Magenta ⚬ Permanent Rose ⚬ Permanent Sap Green ⚬ Prussian Blue ⚬ Quinacridone Red ⚬ Raw Umber ⚬ Sepia ⚬ Turquoise Blue ⚬ Venetian Red ⚬ Vermilion ⚬ Viridian ⚬ Winsor Emerald ⚬ Winsor Violet (Dioxazine) ⚬ Yellow Ochre

MATERIALS

1½-inch (38mm) sable flat brush ⚬ HB lead pencil ⚬ Nos. 000, 00, 0, 1, 2 and 4 sable round brushes ⚬ Rag ⚬ Stretched watercolor paper ⚬ Transferring materials from page 15

1 Sketch your drawing with an HB lead pencil, then transfer it onto stretched watercolor paper.

2 In separate pans, add enough water to Turquoise Blue and Cobalt Blue to make a creamy consistency with each color. Wet the entire picture using a 1½-inch (38mm) flat. Remove excess water by blotting the brush on a rag. Dip the flat in Turquoise Blue and apply it to the area behind the elves. Rinse the brush in clean water and load it with Cobalt Blue. Apply it next to the Turquoise Blue along the outer edge of the painting. Tilt the surface back and forth so the colors blend.

3 Using a no. 00 round loaded with a light tint of Turquoise Blue, paint the most distant tree with small strokes, following the twists in the trunk and branches and keeping in mind that the light source is coming from the center of the background. Do the same to the midground trees using Cobalt Blue. Using a no. 2 round loaded with Raw Umber, paint the foreground tree trunks that are bathed in light.

4 Create a basecoat by mixing Vermilion with Burnt Sienna. Apply a pale tint of this to the elves' skin using a no. 1 round. Using a no. 2 round loaded with Burnt Sienna, paint the boots and tunic of the Elf Prince. Clean the brush, then apply Payne's Gray to his leggings and to the folds of his cape in shadow. Using a no. 1 round loaded with French Ultramarine, paint the folds of the Elf Princess's gown and cape, blending away from the edges with clean water. Using a pale tint of Yellow Ochre and a no. 000 round, paint the shadow areas of the prince's hair. Using a no. 00 round loaded with Sepia, paint the areas of the princess's hair that turn farthest from the light. Using a no. 000 round, apply a medium tint of Caput Mortuum Violet to the straps on the prince's tunic and boots.

5 In a pan, add enough water to Alizarin Crimson to make a creamy consistency. Wet the princess's gown, except for the panel in the front, using a no. 1 round. Let this dry briefly, then use a no. 2 round to apply Alizarin Crimson to the wet areas. Let this dry briefly, then apply more color to the shadowy areas of the folds and let dry. Using a no. 1 round loaded with a light tint of Permanent Magenta, paint the center panel of the gown. Let this dry briefly, then apply a darker tint to the folds in shadow. Load a no. 1 round with Chinese Orange and apply it away from the outer edges of her hair.

Paint the prince's sword handle with Yellow Ochre loaded on a no. 000 round. Using a no. 2 round, apply a medium tint of Burnt Sienna to the prince's tunic and boots. Use a no. 0 round to apply Chinese Orange to the straps on his tunic and boots. Use a no. 0 round to apply Yellow Ochre to his cape fastener.

Apply a very light pale tint of Quinacridone Red to the elves' skin with a no. 1 round. Wet the princess's cheek then apply a tint of Quinacridone Red with a no. 000 round.

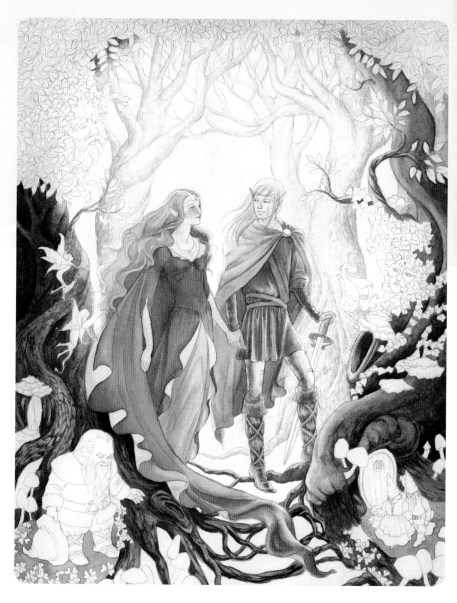

6 Using a light tint of Permanent Rose loaded on a no. 0 round, paint the outside of the cape and the outer folds of the princess's gown. Using a no. 0 round loaded with Winsor Violet (Dioxazine), paint the inside of the prince's cape.

Using a no. 2 round loaded with Burnt Sienna, paint the tree trunk and roots on the right. Let this dry briefly, then dab on Oxide of Chromium for a mottled effect. Let this dry briefly, then use a no. 0 round loaded with Sepia to paint the crevices in shadow and let dry. Using a no. 000 round loaded with Sepia, paint irregular patterns to suggest the bark of the tree. Paint the tree on the left in the same manner, keeping in mind the light source. Mix together a medium-dark shade of Viridian and Oxide of Chromium. Using a no. 1 round, apply this to the forest floor under the gnomes and dwarf.

7 Using the mixture of Viridian and Oxide of Chromium from Step 6, paint the area of the ground between the tree roots that looks like natural steps with a no. 2 round. Let this dry then apply Cobalt Blue over the mixture. Using a darker shade of the Viridian and Oxide of Chromium mixture, paint tiny vertical strokes of texture to the forest floor with a no. 000 round.

Apply a medium tint of Oxide of Chromium on the entire top grassy "stair" using the no. 000 round. Let this dry, then dab on a darker shade for texture. On the forest floor behind the couple, apply a light tint of Viridian, ending at the base of the distant tree.

8 Using a no. 4 round loaded with clean water, wet the foliage at the top of the painting. Dab off excess water on a rag, then apply a medium tint of Olive Green to the inside edge of the foliage. Let this dry briefly, then apply Permanent Sap Green next to the Olive Green, then Hooker's Green next to that and ending at the outer edge with Viridian. Let this dry. Wet the ivy on the right with clean water. Using a no. 2 loaded with Olive Green, paint the inner edge of the foliage. Then apply Hooker's Green to the shadow areas of the ivy. Apply Olive Green to the ivy behind the birds' nest, using a no. 00 round. Use a no. 00 round and a pale tint of Burnt Sienna to paint the bird's nest and add a dark tint of Sepia to the areas of the nest in shadow. Paint the eggs Turquoise Blue with a no. 00 round.

9 Using a no. 1 round, apply Chinese Orange to the shelf fungus growing on the sides of the foreground trees. Using a no. 000 round, paint the mushrooms on the ground with a pale tint of Yellow Ochre. Let this dry briefly, then apply Winsor Violet (Dioxazine), starting at the edge of the caps and lifting the brush upward to end with a fine line.

Paint the clover with Olive Green, using a darker tint for the shadows with a no. 000 round. Apply a pale tint of Burnt Sienna to the door behind the dwarf, applying a darker shade of Burnt Sienna to the areas in shadow. Add details to the door with Cadmium Yellow Deep and a no. 000 round.

Apply the fleshtone from Step 5 to the dwarf using a no. 0 round and let dry. Apply Yellow Ochre to his collar, cuffs, boots and hat using a no. 0 round. Let this dry, then apply Burnt Sienna to the rest of his jacket and pants and Chinese Orange to his hair. Paint his cheeks with Quinacridone Red.

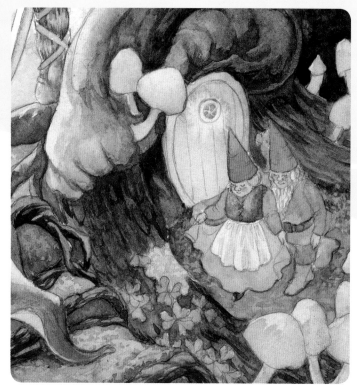

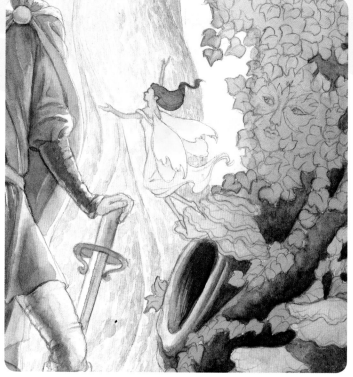

10 Paint the shelf fungus and mushrooms as you did in Step 9. Create a fleshtone by mixing Vermilion with Burnt Sienna and apply this to the gnomes' skin. Blend in Quinacridone Red for their cheeks.

Paint Mrs. Gnome's outfit using a no. 000 round and Yellow Ochre for her shirt and hair, Burnt Sienna for her vest and shoe, a light tint of Cobalt Blue for the shadows of her apron and Winsor Violet for her skirt. Let the colors dry between applications.

Paint Mr. Gnome's outfit using Cobalt Blue for his shirt, Yellow Ochre for his boots and Sepia for his pants. Let the colors dry between applications. Paint the stovepipes using a no. 000 round loaded with Indigo. Paint the holes of the leaf curtains in the gnomes' doorway with Cadmium Yellow and a no. 000 round. Using the no. 000 round, apply a light tint of Indigo to the shadow areas in his beard and hair.

Using a no. 000 round and a light tint of Indanthrene Blue, paint the door and lichen. Clean the no. 000 round and use it to apply a medium tint of Olive Green to the clover.

11 Using a no. 4 round loaded with clean water, wet the foliage along the side of the painting. Dab off excess water on a rag, then apply a medium tint of Olive Green to the inside edge of the foliage. Let this dry briefly, then apply Permanent Sap Green next to the Olive Green, then Hooker's Green next to that and ending at the outer edge with Viridian.

Using a no. 000 round loaded with French Ultramarine, paint the shadow side of the Elf Prince's sword blade. Apply a dark shade of Yellow Ochre with a no. 000 round to the sword handle. Paint the dress of the sprite on the right with a light tint of Permanent Rose loaded on a no. 000 round. Let this dry briefly, then apply a darker tint where it turns from the light. Let dry. Paint her wings Cadmium Yellow, blending toward the end of the wings with clean water. Paint her hair a medium tint of Ivory Black.

Mix Cadmium Red with Burnt Sienna and apply a pale tint of this to the sprites' skin with a no. 000 round.

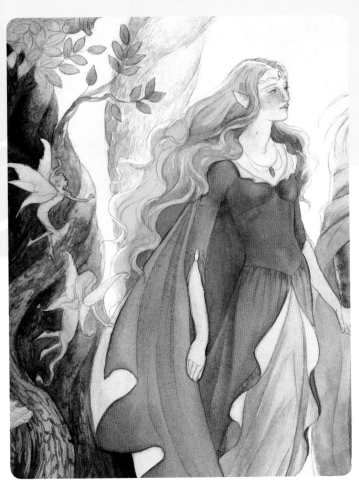

12 Using a no. 000 round loaded with Quinacridone Red, paint the Elf Princess's cheeks and let dry. Use the no. 000 round to apply Alizarin Crimson to the jewel in her necklace.

Using a no. 000 round, paint the gown of the sprite on the left with Cadmium Yellow and let dry. Paint her wings a light tint of Yellow Ochre. Using the no. 000 round and Winsor Emerald, paint the gown of the other sprite. Let this dry briefly, then apply a darker tint of the color to the folds that are turned from the light. Let dry, then paint her wings Cadmium Yellow. Using a no. 000 round loaded with a mixture of Vermilion and Burnt Sienna, paint the sprites' skin.

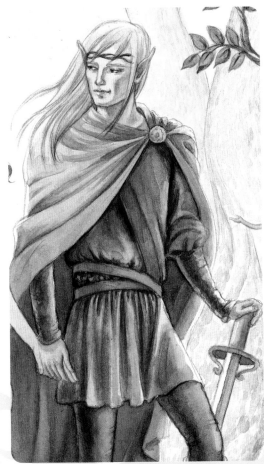

13 Mix together Cadmium Yellow and Chinese White and apply this to the areas of the prince's hair in shadow using a no. 000 round. Mix together Indigo and Caput Mortuum Violet and apply this to the areas of his skin in shadow, using a no. 000 round. Add a touch of Vermilion to his cheekbones and lips and Cobalt Blue to his irises using a no. 000 round. Rinse the no. 000 round in clean water, then apply a dark tint of Winsor Violet to the folds of his cape. Using a no. 0 round, apply Caput Mortuum Violet to his leggings. When the shine is gone, apply a darker tint of the color where the folds turn from the light. Using a no. 000 round, apply Chinese Orange to the straps on this tunic and boots. Using a no. 1 round, apply Cobalt Blue inside his cape.

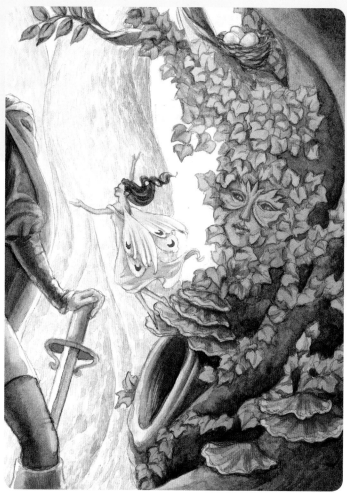

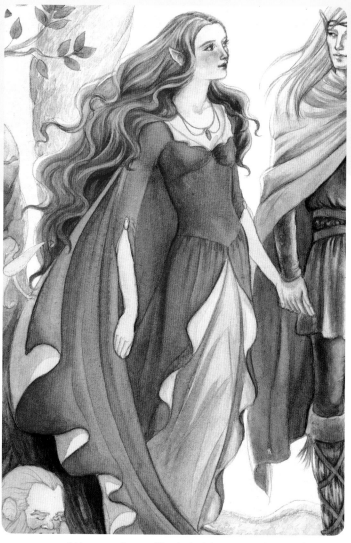

14 Using a no. 000 round loaded with Oxide of Chromium, paint the spaces under the ivy leaves on the right.

With a no. 000 round, apply Yellow Ochre to the wing contours of the sprite on the right. Let this dry, then apply Ivory Black markings to the wings, using the same brush.

Using a mixture of Venetian Red and Brown Madder, paint the contours of the shelf fungus on the foreground trees with a no. 000 round.

Using a no. 000 round, paint the twigs of the nest in shadow with a medium tint of Indigo.

Using a no. 000 round, paint the shadow areas of Green Woman's face with Olive Green.

15 Using a no. 2 round loaded with Quinacridone Red, paint the princess's hair. Let this dry briefly, then, with a mixture of Cadmium Red Deep and Brown Madder, paint the strands of her hair in shadow. Paint her lips Quinacridone Red and her eyes Burnt Umber, using a no. 000 round. Use a no. 000 round to apply Cadmium Yellow to the chain of the princess's necklace and let dry.

Since the princess already has on a lovely necklace, I decided to edit out the crown I had sketched. Simply erase the crown with a kneaded eraser to remove it.

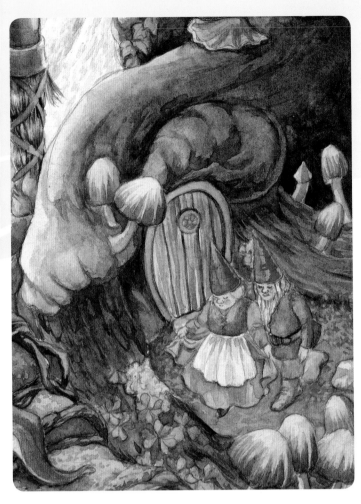

16 Using a no. 000 round, apply darker shades of the colors used for Mr. and Mrs. Gnome's clothing in Step 10 where they are turned from the light.

Using a no. 000 round, apply a darker tint of Winsor Violet to the mushrooms on the forest floor. Clean the brush, then create the grain of wood on the door of the gnomes' home with Indian Red.

17 Using a dark tint of Olive Green loaded on a no. 0 round, paint the shadow areas of foliage at the top of the composition. For the leaves that receive even less light, use Hooker's Green. For the leaves in deepest shadow, use Viridian.

18 Using a no. 000 round loaded with Olive Green, paint the areas of the Green Man in shadow and let dry. Using a no. 2 round, apply a pale tint of Prussian Blue over his face and the surrounding ivy. Let this dry briefly, then paint the ivy next to the tree foliage with a pale tint of Indigo and a clean no. 2 round. Using a no. 000 round, add Indanthrene Blue between the leaves at the top.

19 Paint the wing contours of the sprite on the left with French Ultramarine, and apply Winsor Emerald to the wing contours of the sprite just below that one. Using a no. 000 round, add a darker tint of Winsor Emerald to the shadows on the green dress of the sprite on the bottom left.

20 Using a no. 1 round loaded with a darker shade of Yellow Ochre, paint the gnome's collar, cuffs, boots and hat. Let this dry. Using a no. 1 round loaded with a dark tint of Burnt Sienna, paint the folds of his jacket and pants in shadow and let dry. Using a no. 000 round loaded with Chinese Orange, paint his belt and boot straps.

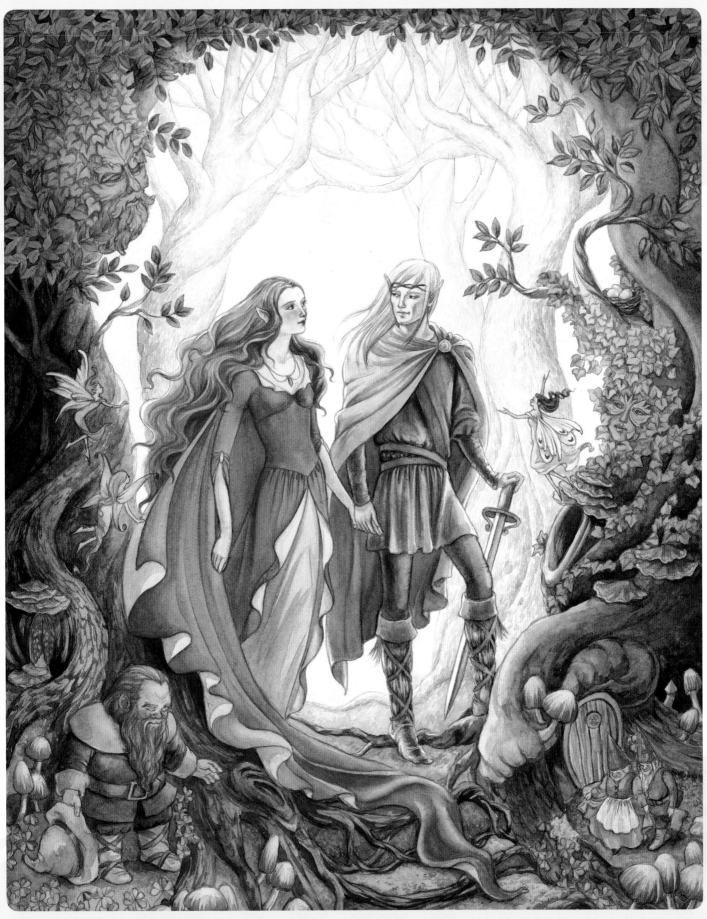

21 Using an HB lead pencil, draw the features and define the outer edges of all the characters, mushrooms, tree and foliage.

INDEX

Bring fantasy worlds to life with IMPACT

You'll love the charming fairies presented in *Enchanting Fairies*. Start by learning to draw children, adolescents and adults, then add elements such as wings and point ears to create fairies with sweetness and mischief. Demonstrations feature individual fairies and groups, from simple subjects without backgrounds to those with background elements. From playing in a sun-drenched field of wildflowers to hiding by a shady woodland strea, or dancing among smowflakes, you can capture the essence of fairies with the tips and techniques provided in this book.

ISBN-13: 978-1-58180-956-5; ISBN-10: 1-58180-956-5, paperback, 128 pages, #Z0667

Learn how to create every aspect of fantastic fairies and their worlds, professional artist David Adams. This fun and informative guide covers basics, color theory and how to create important fairy details including anatomy, wings, poses, flowers, trees, butterflies, water and more. With beautiful finished art throughout and a gallery of paintings, you'll be inspired to create your own beautiful fairy art.

ISBN-13: 978-1-60061-089-9; ISBN-10: 1-60061-089-7, paperback, 128 pages, #Z1978

Dreamscapes is a unique guide to painting beautiful watercolor angels, faeries and mermaids in their own worlds (celestial, woodland, garden and seascapes) step by step. Fantasy artist Stephanie Pui-Mun Law walks you through her process, showing and describing her techniques for creating fantasy scenes full of wonder and mystery. You will begin by learning about essential materials, including brushes, paints and paper, then move on to important techniques such as planning and sketching; figure proportions; specific characteristics of angels, faeries and mermaids; developing backgrounds; and finishing techniques that add an air of magic.

ISBN-13: 978-1-58180-964-0; ISBN-10: 1-58180-964-6, paperback, 176 pages, #Z0688

These and other fine IMPACT books are available at your local art & craft retailer, bookstore or online supplier or visit our website at www.impact-books.com